YOU

VISIT

RELAX

EXPLORE

IMAGINE

WRITE

THINK

DRAW

ART

BE

U

I HOPE YOU FILL UP YOUR BOOK WITH LOTS OF "YOU" AND THEN SHARE IT WITH OTHERS SO THEY CAN GET TO KNOW YOU BETTER THAN THEY ALREADY DO...

MUCH LOVE & HAPPINESS!!!

YOUR NAME GOES ON THIS LINE

WORK

PLAY

PASSION

. . .

..

.

WHAT ARE YOUR THREE WORDS?

WRITE THEM ABOVE

another day in
NICEVILLE

EXPLORE • IMAGINE • WRITE • DISCOVER • DRAW

draw something nice or not nice in this box

JIM CLARK
. . .

NOTES FOR WRITING YOUR BOOK

what will your book's name be? will it be fiction or non-fiction? will it be your life story of fame and fortune or a romantic love story? start writing

This book is a work of creative fun for me, hopefully a little work/reward for you, and your personal piece of art to share with others. Many people helped me make this book happen through motivation, memories, and thoughts in my head and I thank all of you who did and you know who you are. :)

Copyright © 2019 by Jim Clark
another day in Niceville
www.anotherdayin.com

All rights reserved, including the right to reproduce this book
or portions thereof in any form whatsoever.

Editor ~ Mara Clark @careermystyle Layout/Design by www.juststay.com
Photos by Jim Clark @iamjimclark of www.iamjimclark.com

ISBN: 978-1-79477-001-0

ENJOY PHOTOGRAPHY

THINK ABOUT STUFF

WRITE WORDS DOWN

SPACES TO DRAW ON

CREATE ART TO SHARE

time to think and doodle outside the box

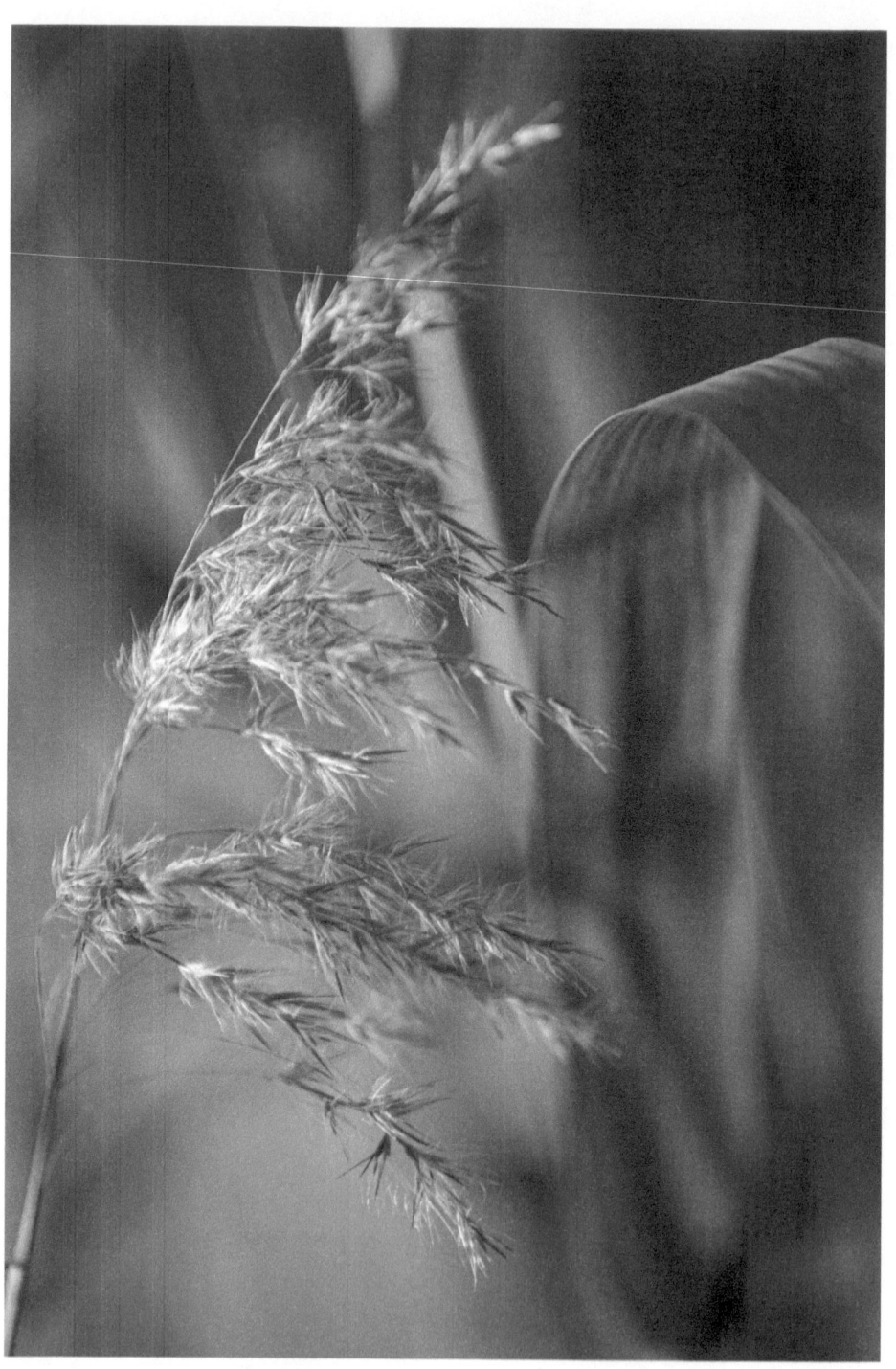

"BOGGY BAYOU FOLAGE"

©2019 JIM CLARK

INTRODUCTION

blah blah blah... this book is going to be about you not me. start writing your introduction here. my name is _____ and here's a few things you might like to know about me.

DEDICATION

why did I do this? I put this little book together to share my photos with people as well as to give them the opportunity to learn something about themselves. writing or drawing can help you look inside yourself and explore things you haven't thought about lately or ever at all. you might just enjoy looking at the photos of Niceville, seeing folks who live here, exploring the boggy bayou, nature, and wildlife. that's ok too.

who are you going to share your book with? write their names down here:

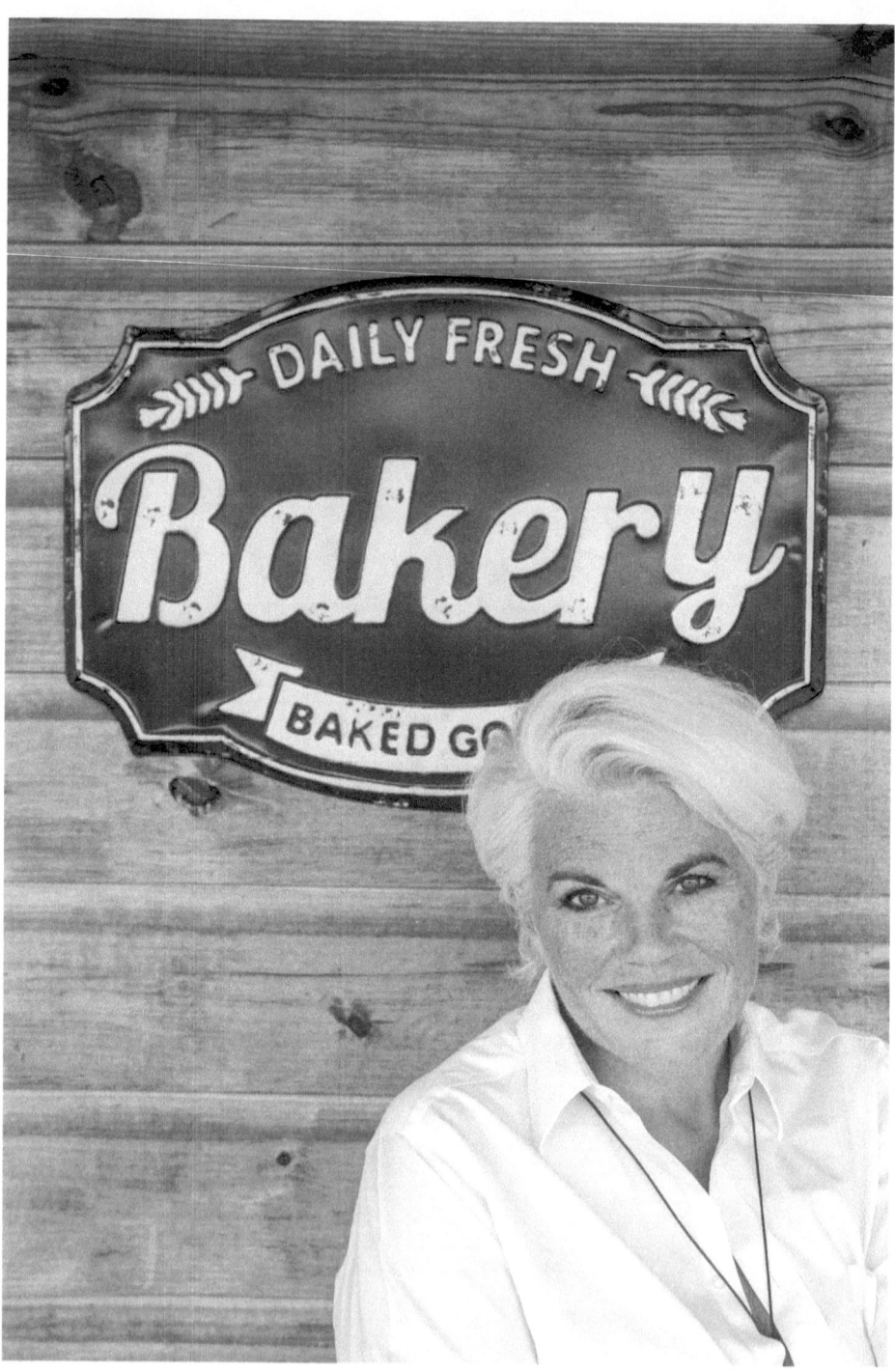

"SHARE THE LOVE" @createwithbigorangehousedesign ©2019 JIM CLARK

HOW DOES THIS WORK?

well, it's your book now so you can do whatever you want with it. you can write in it, draw in it, tape stuff on it, compose your thoughts, and anything else your heart desires. do it and then share it with others.

I hope you take time to enjoy the photos in the book as much as i enjoyed taking them. remember the good times by the bay, maybe even the bad times, because we all learn from our mistakes, right? hopefully we do or did or will someday soon. you only have one life so live it to its fullest.

draw or tape something here

another day in Niceville

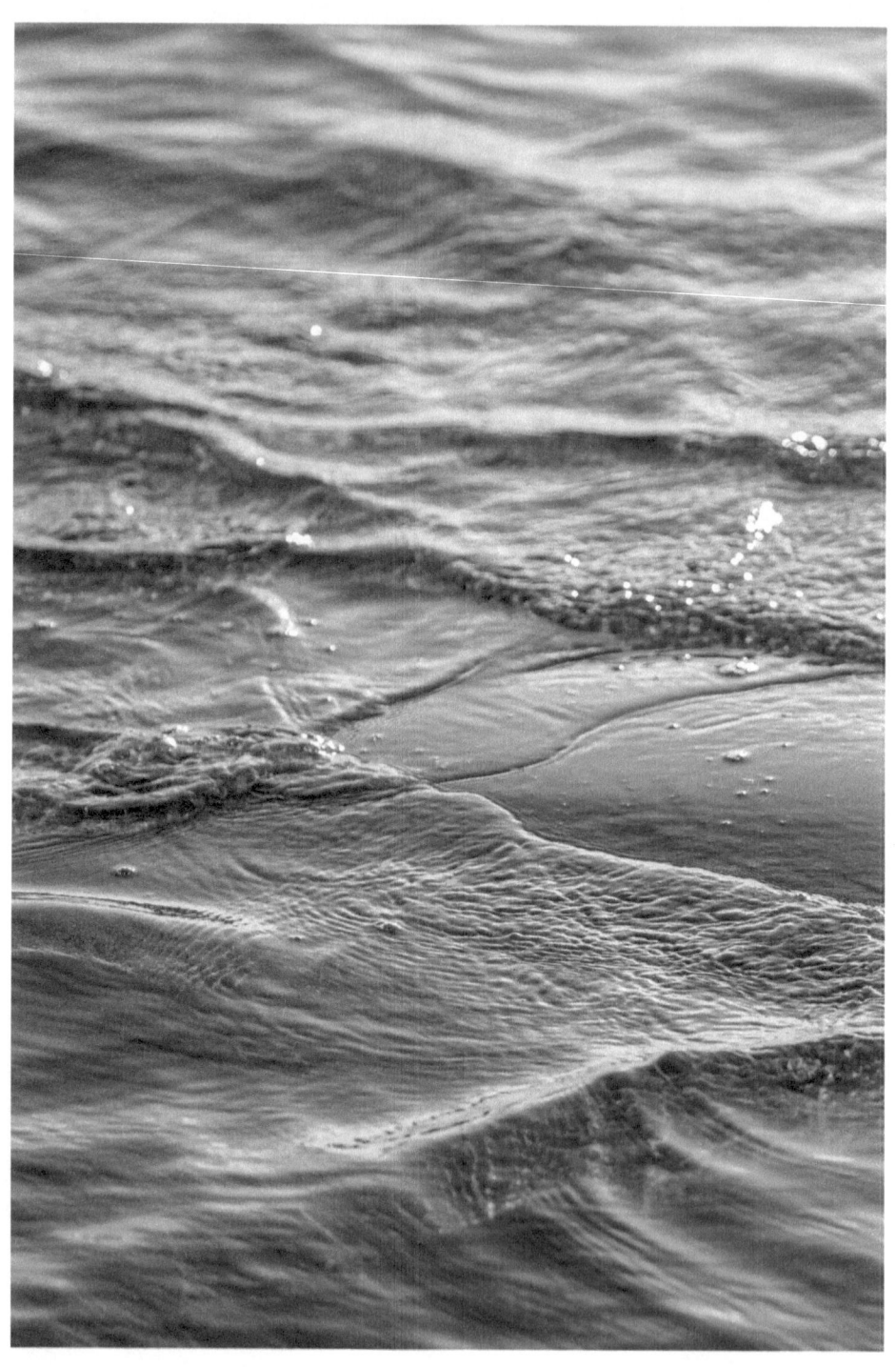

"BREAKING ON THE BAY BY YOU"

©2019 JIM CLARK

WHAT DO YOU DO TO RELAX?
it's an easy question to answer and you may have many things to list

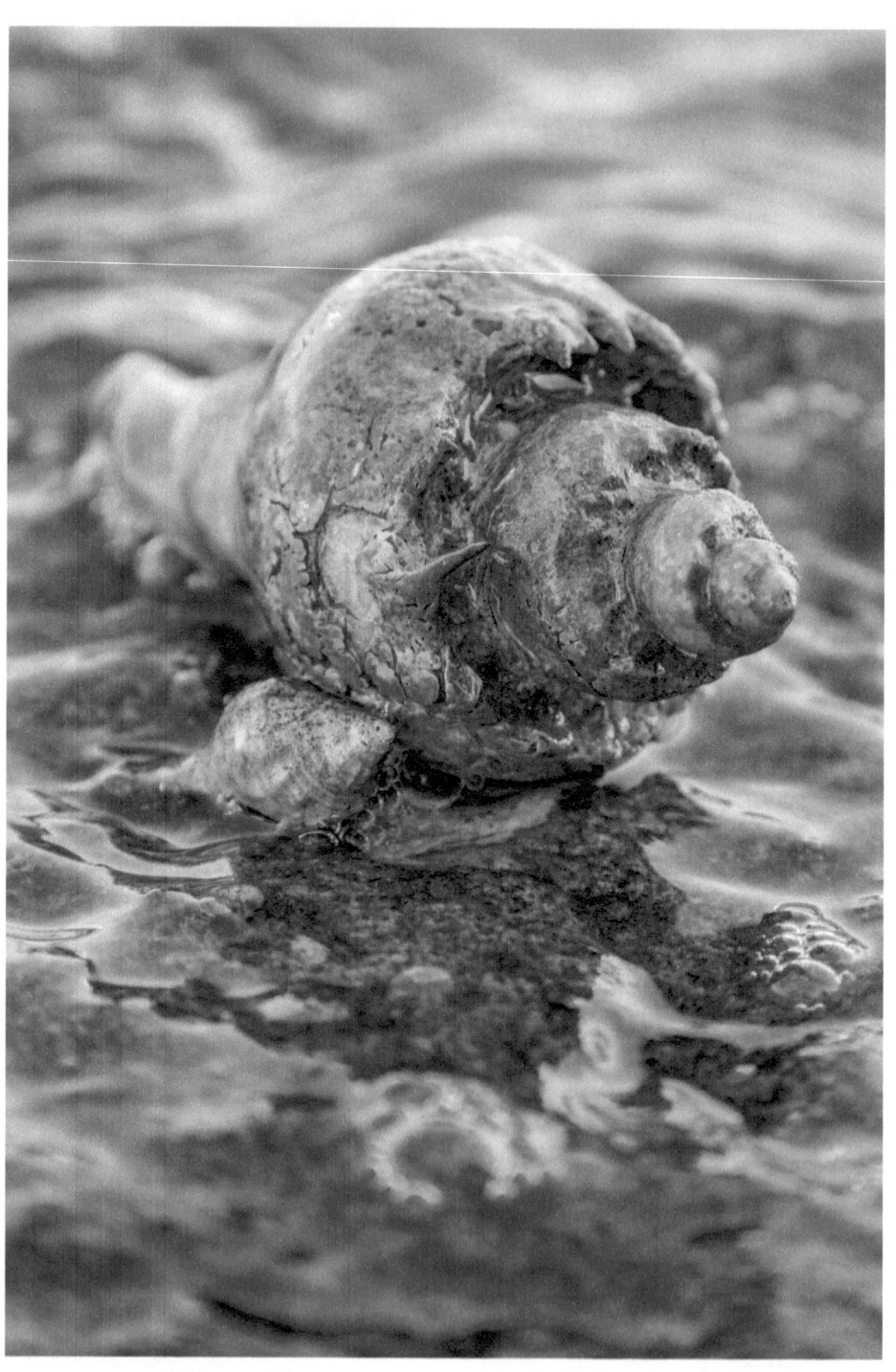

"FATHER AND SON HERMIT CRABS"

©2019 JIM CLARK

THE DESTINATION OR THE JOURNEY?
we all heard it before... write what you think it means

what would you take with you if you had to leave home today
and only had your car to pack it in?

another day in Niceville

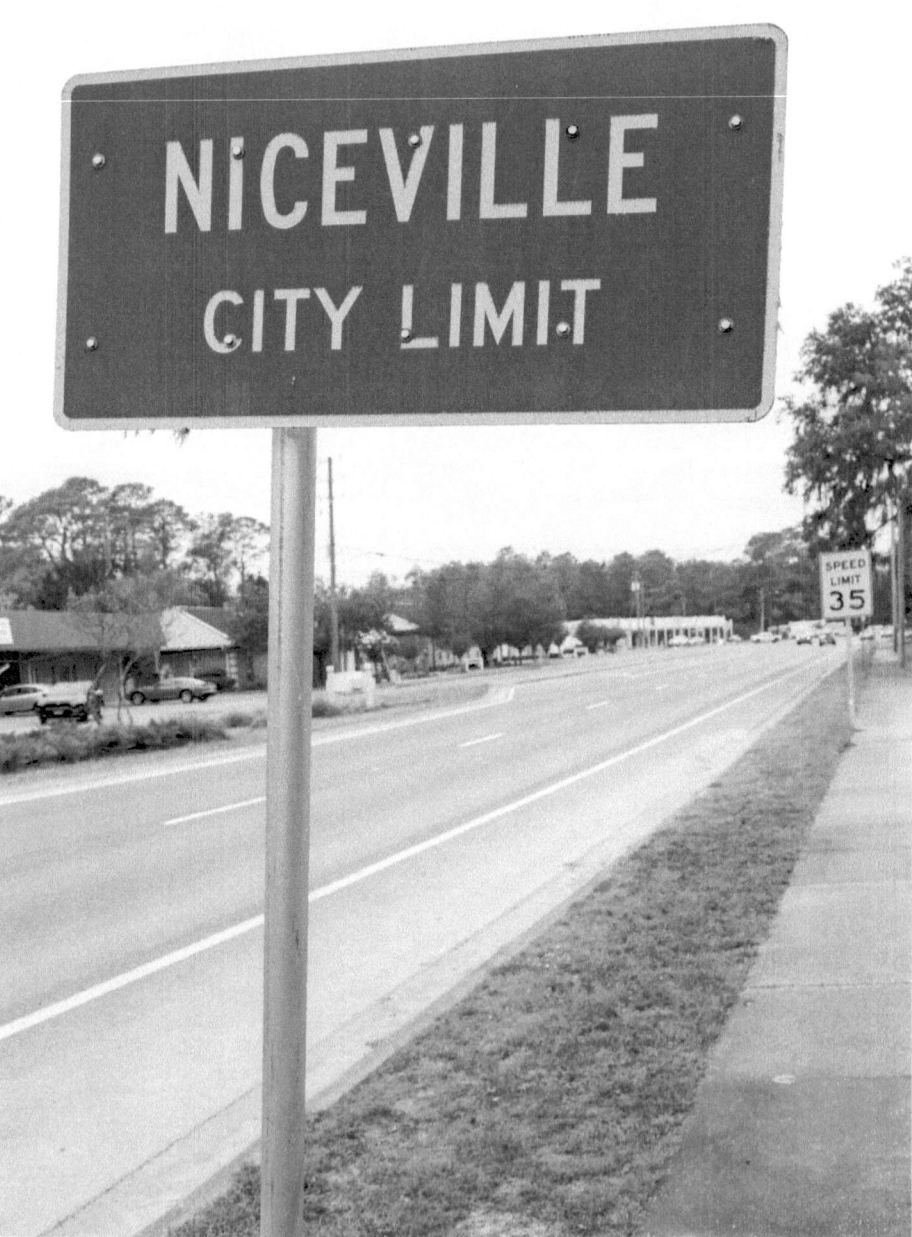

"ARE YOU HERE?"

©2019 JIM CLARK

ARE PEOPLE REALLY NICE IN NICEVILLE?

do you live here? are you nice? let us know what makes a nice person nice, write the names of some nice people you know, and what you think makes them nice?

another day in Niceville

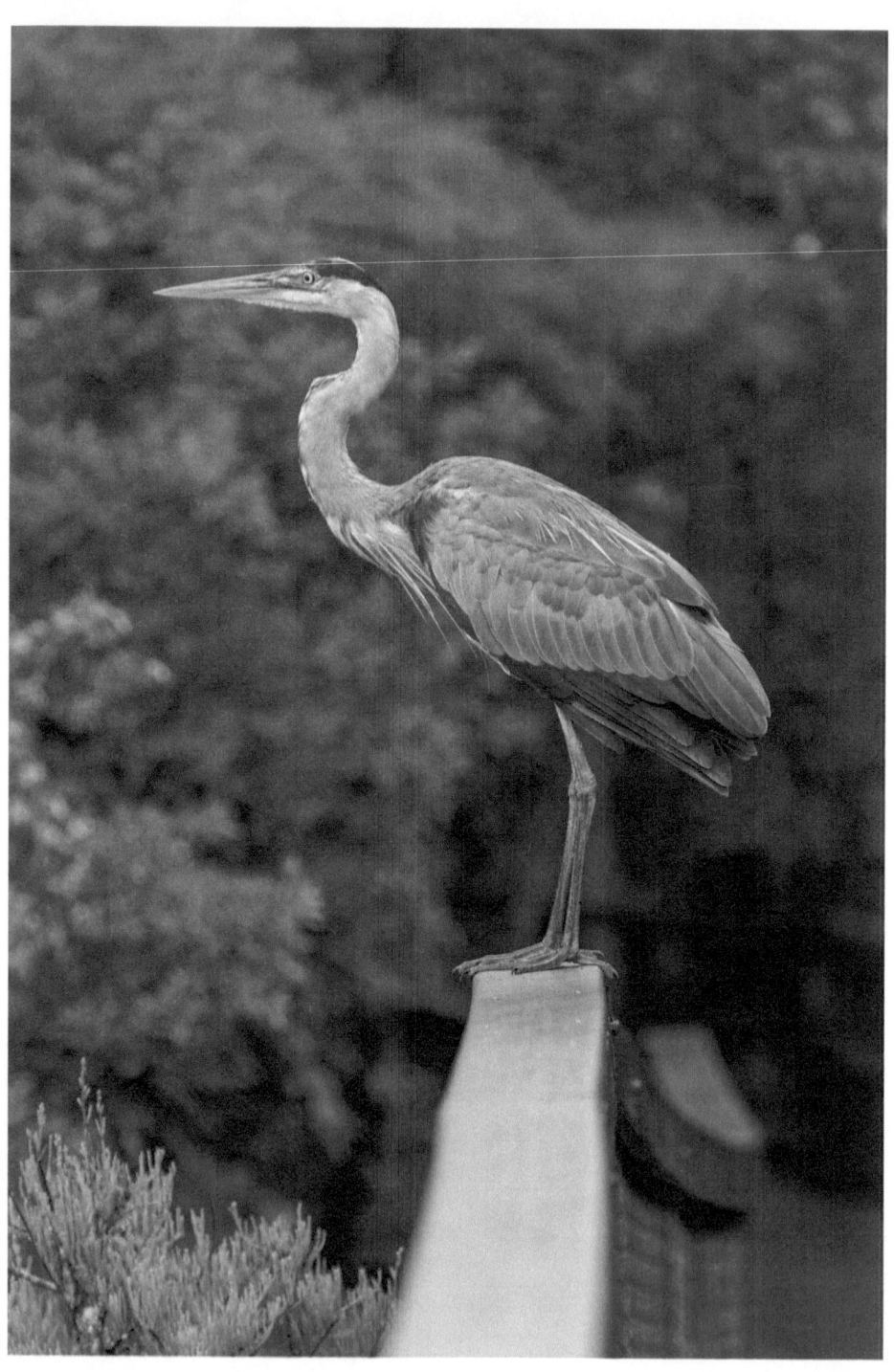

"BLUE HERON BREAK"

©2019 JIM CLARK

HAVE YOU BEEN TO TURKEY CREEK?
what did you like the most about it? did you swim in it?
was the water cold?

draw something below that you saw while there

another day in Niceville

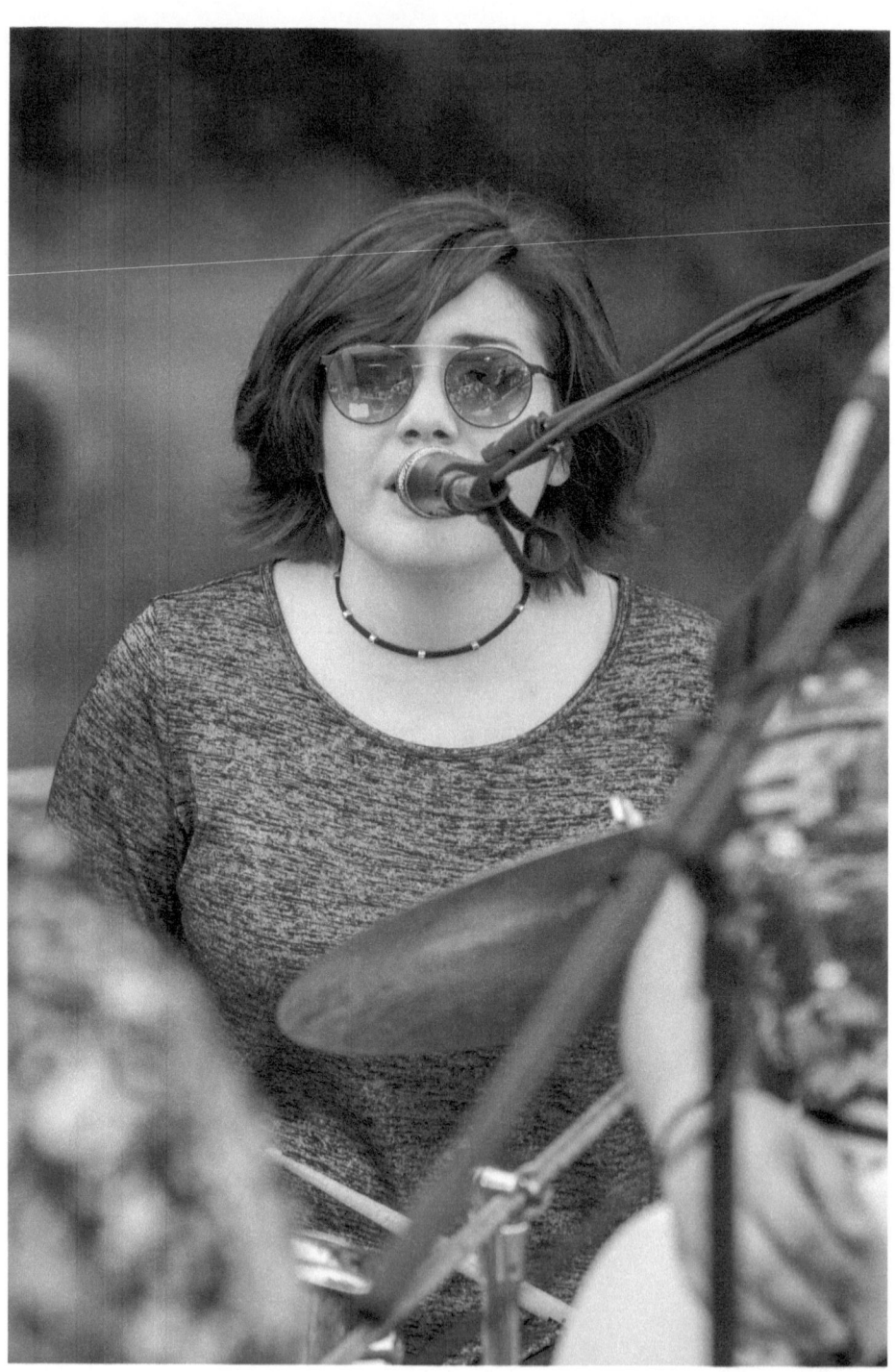

WHAT INSTRUMENT DO YOU PLAY?
if you don't currently play one, pick one and tell us why you picked it.
and if you were in a band where would be your dream tour?

another day in Niceville

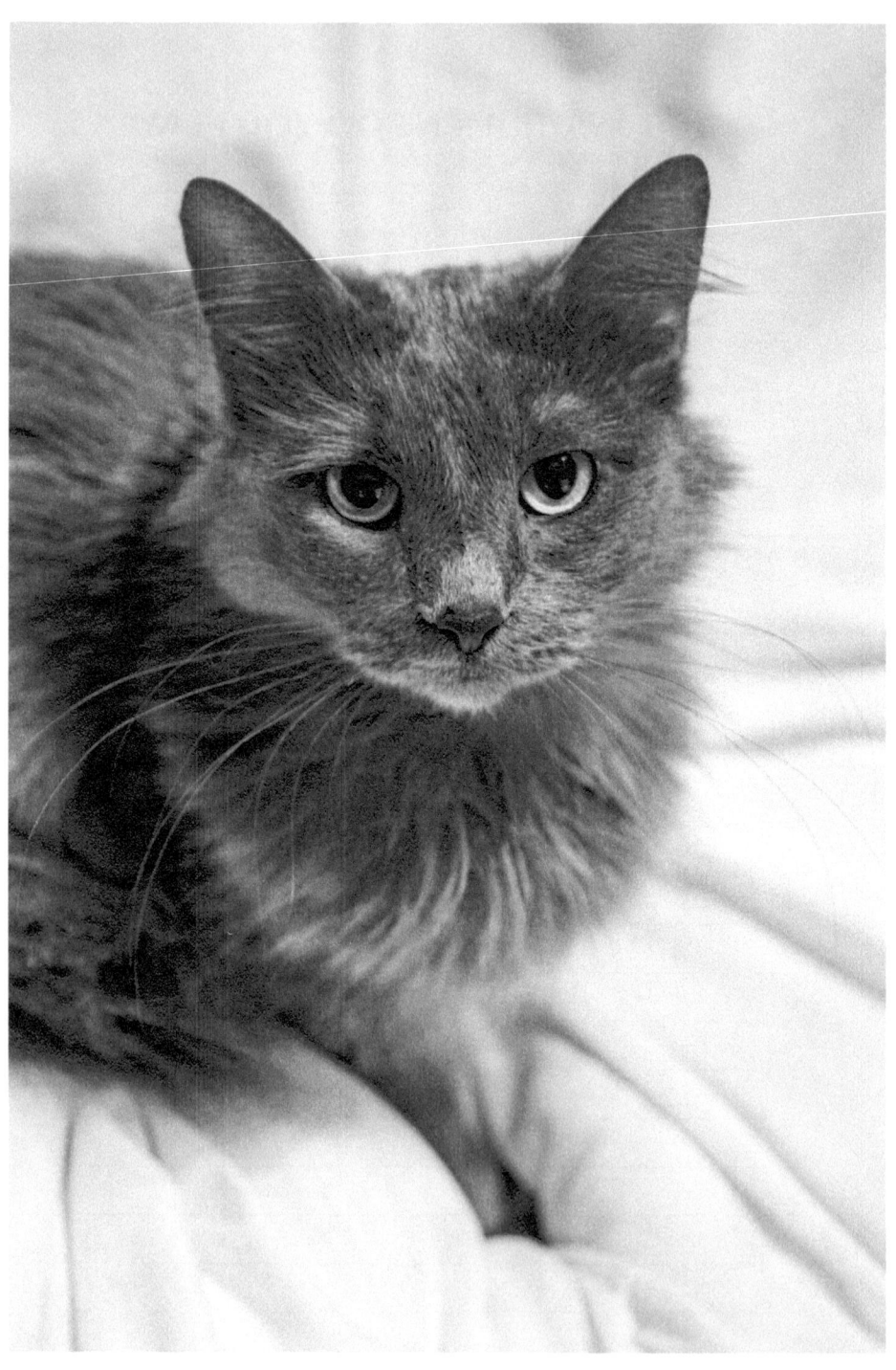

"MISTY DAY"

©2019 JIM CLARK

IF YOU WERE A CAT...
what would your name be? what would you do all day?
what would you look like?

what would you do to the people you live with to aggravate them?

another day in Niceville

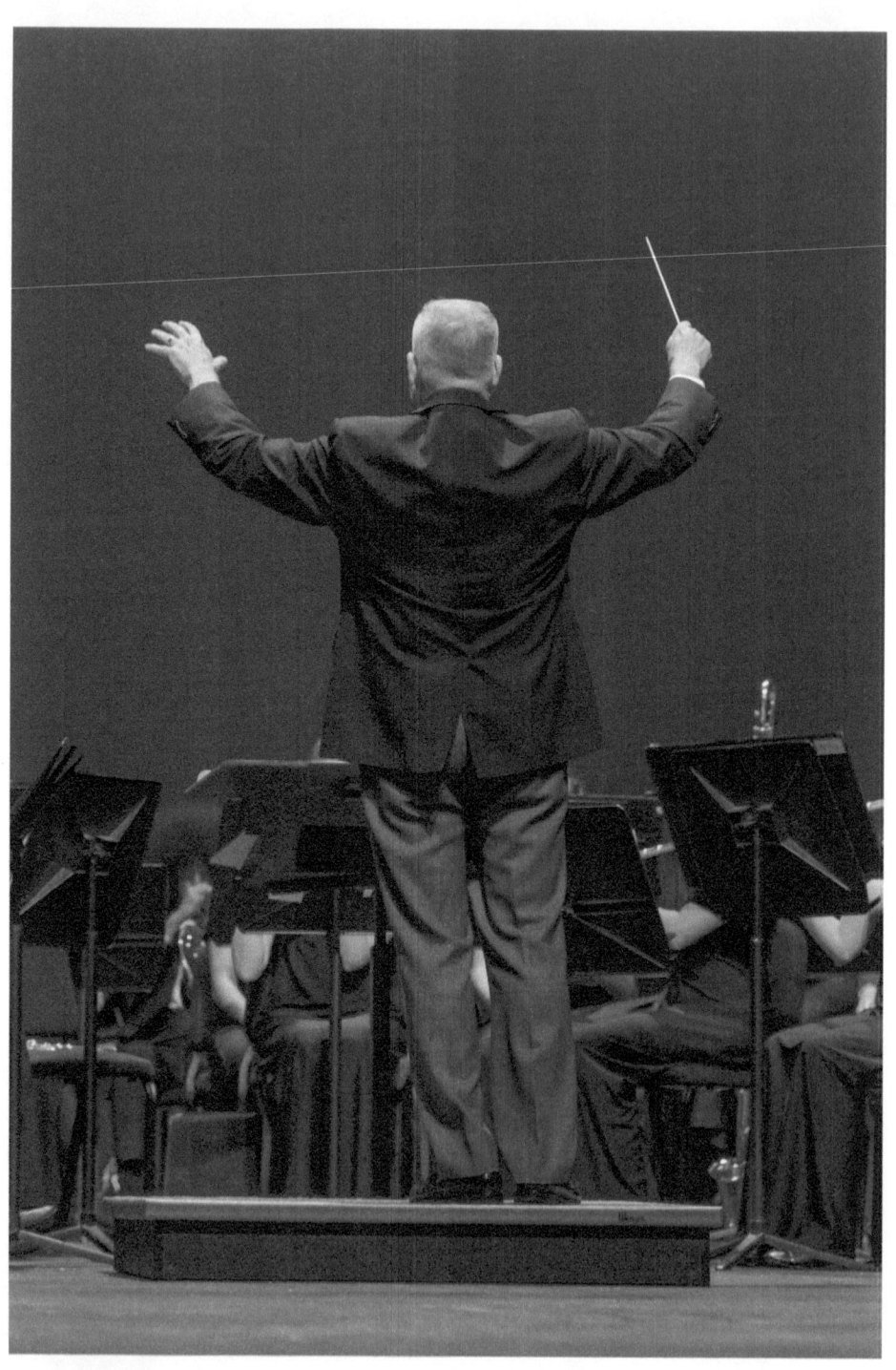

"THE CONDUCTOR"

©2019 JIM CLARK

ARE YOU A LEADER OR A FOLLOWER?
share with us how you lead and what makes a good leader.
there is nothing wrong with being either one or both

another day in Niceville

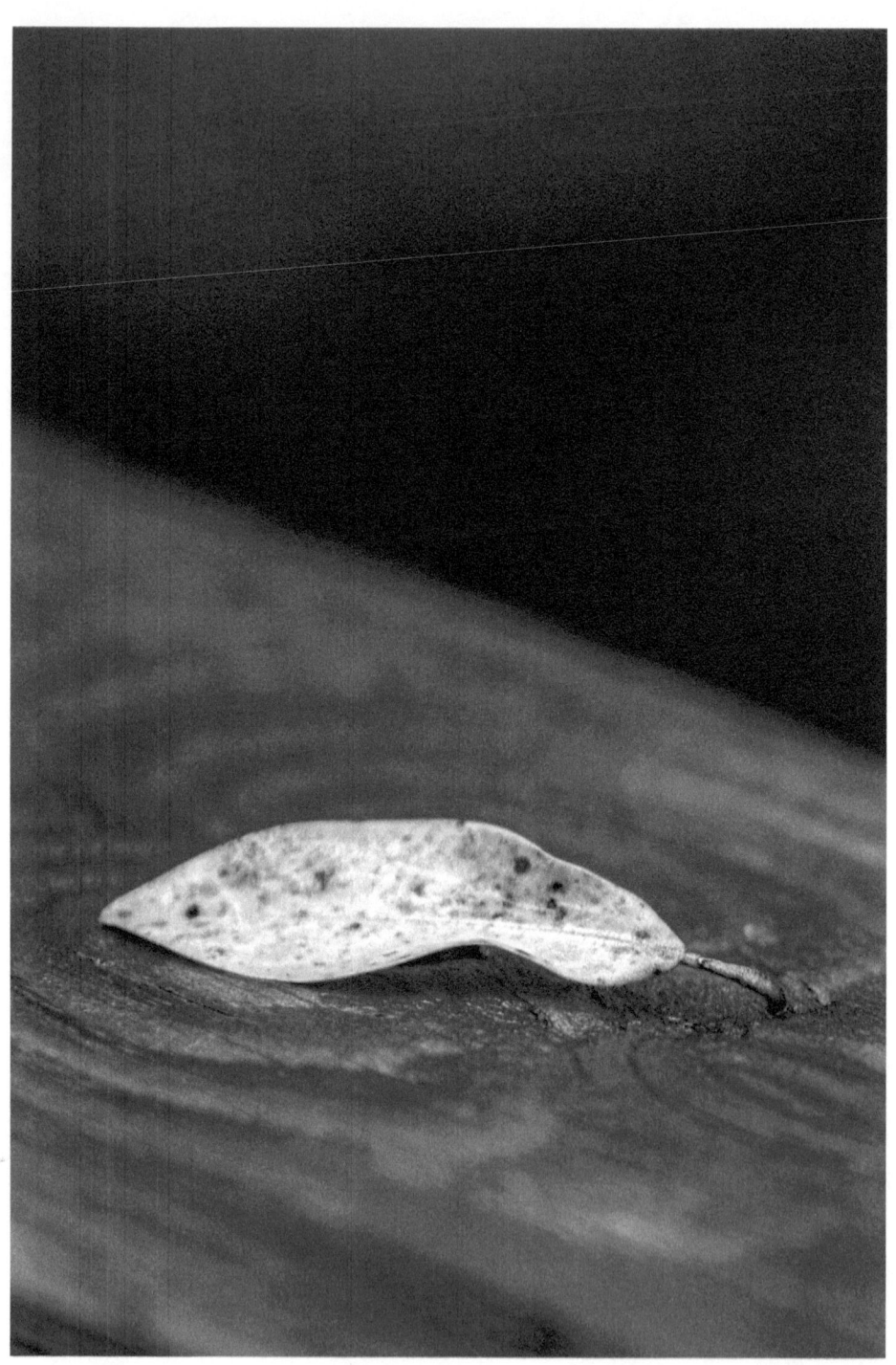

"IT FELL IN THE FALL" ©2019 JIM CLARK

DRAW SOME LEAVES
make them big or small, on a tree, floating in the air or on the ground.

have you ever dried leaves or flowers in a book? what kind? did you do it with someone close to you, to remind you of someone, or just for fun?

another day in Niceville

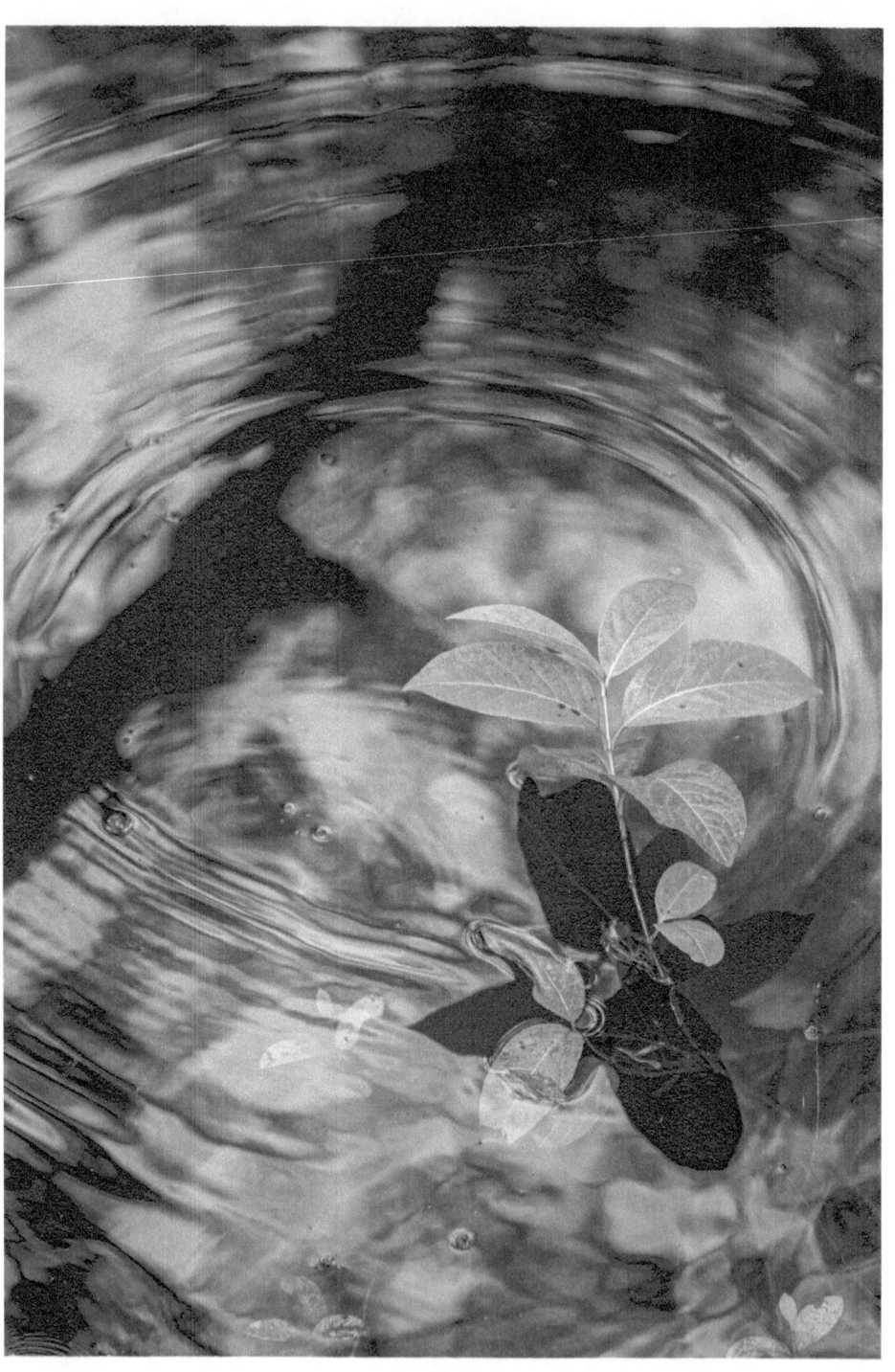

"RIPPLES" ©2019 JIM CLARK

WHAT DOES YOUR REFLECTION SAY ABOUT YOU?

look into your reflection and write what you see. what would you like to see? or better yet, write what you would like others to see in you.

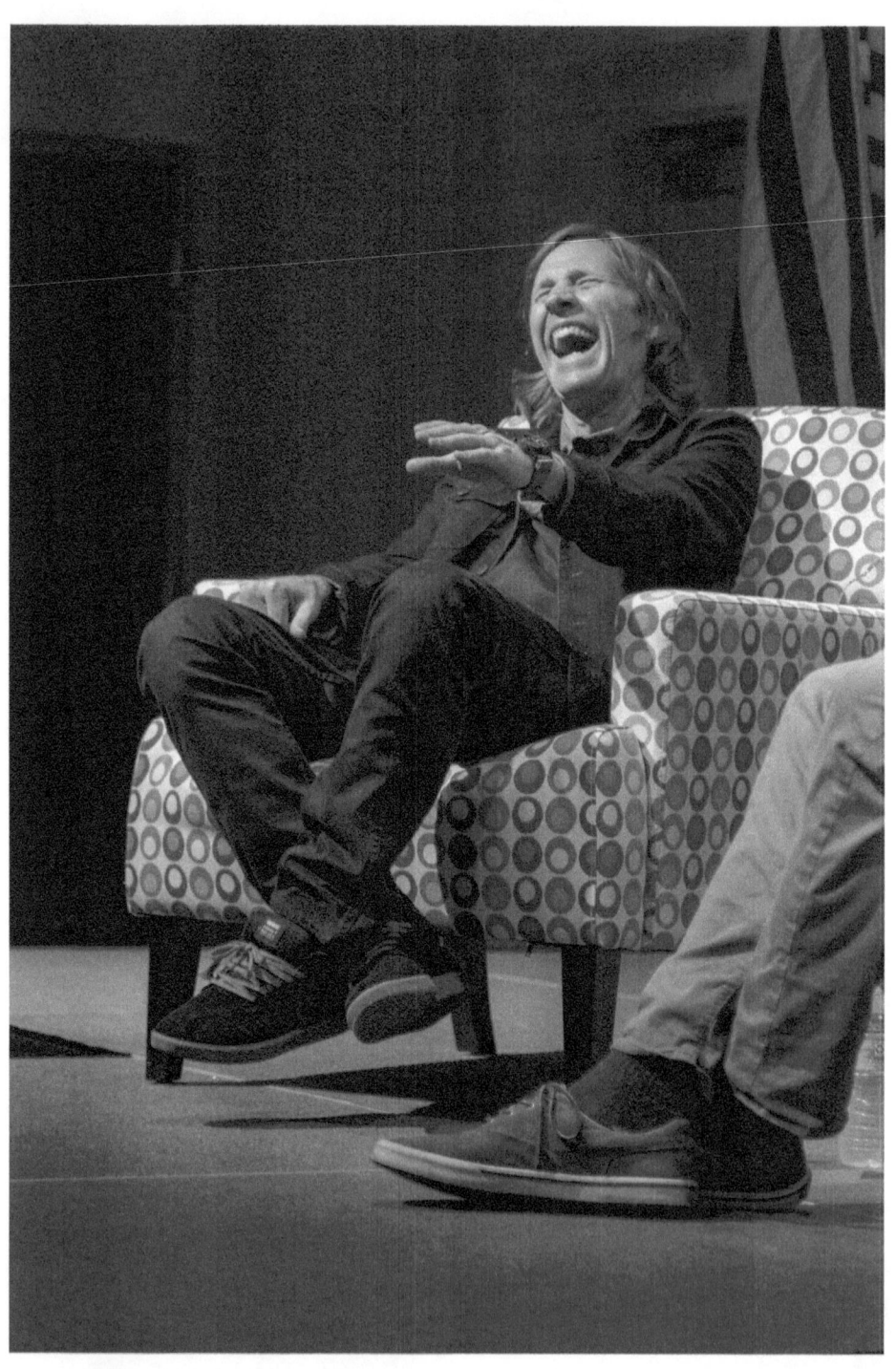

"THE GRANDFATHER OF MODERN SKATEBOARDING" @rodneymullen ©2019 JIM CLARK

WHAT MAKES YOU LAUGH OUT LOUD?
is it a silly joke, your pet chasing its tail, or something else?

draw something funny below and laugh out loud :)

another day in Niceville

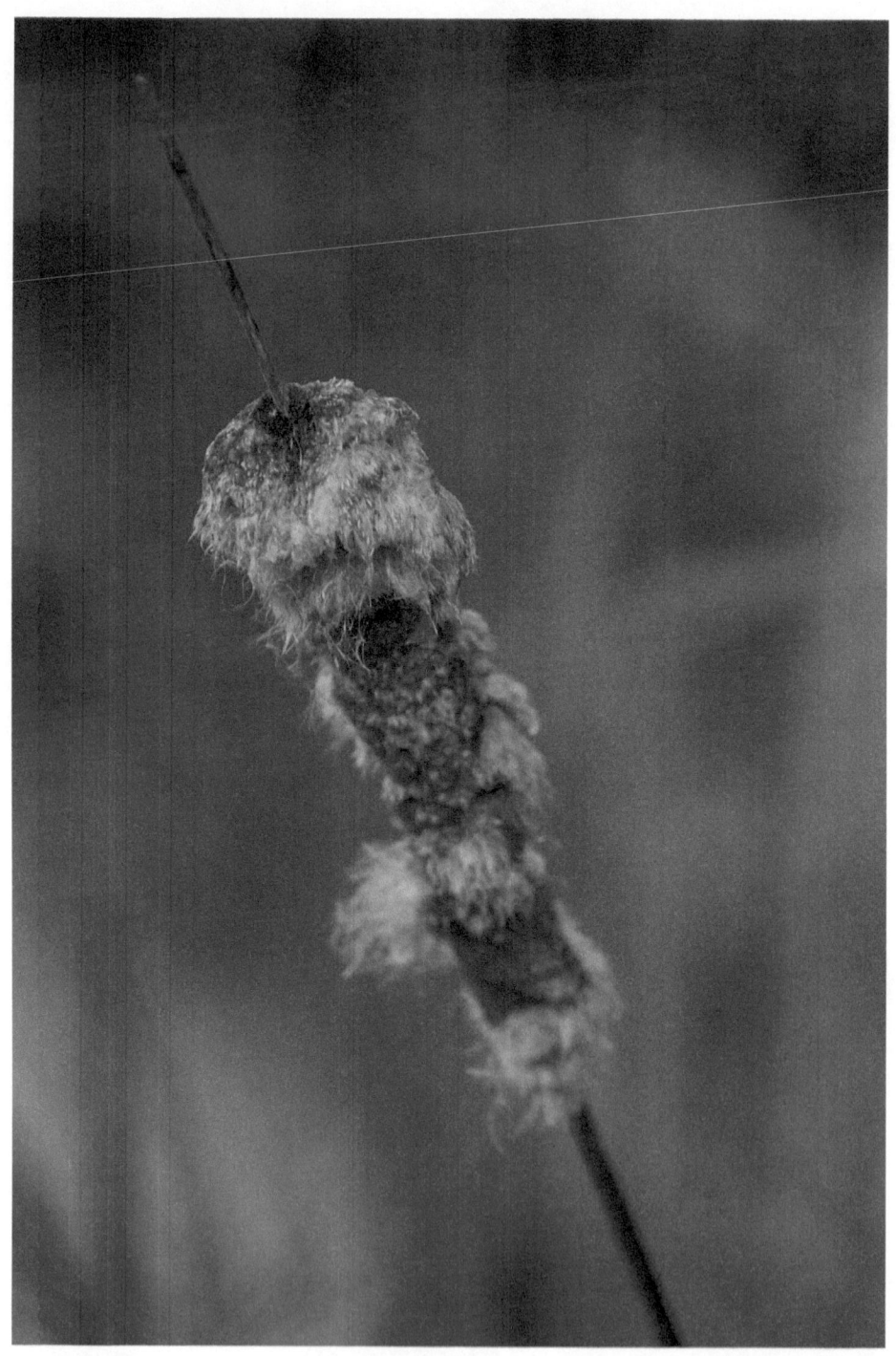

"IT'S SO FLUFFY" ©2019 JIM CLARK

WHAT'S YOUR FAVORITE SENSE?
share with us. is it your sense of sight, smell, taste, hearing or touch?

"FAMILY TREE"

©2019 JIM CLARK

WHO IS IN YOUR FAMILY TREE?
start creating yours below from your memory and then start asking your family members to find even more memorable people

another day in Niceville

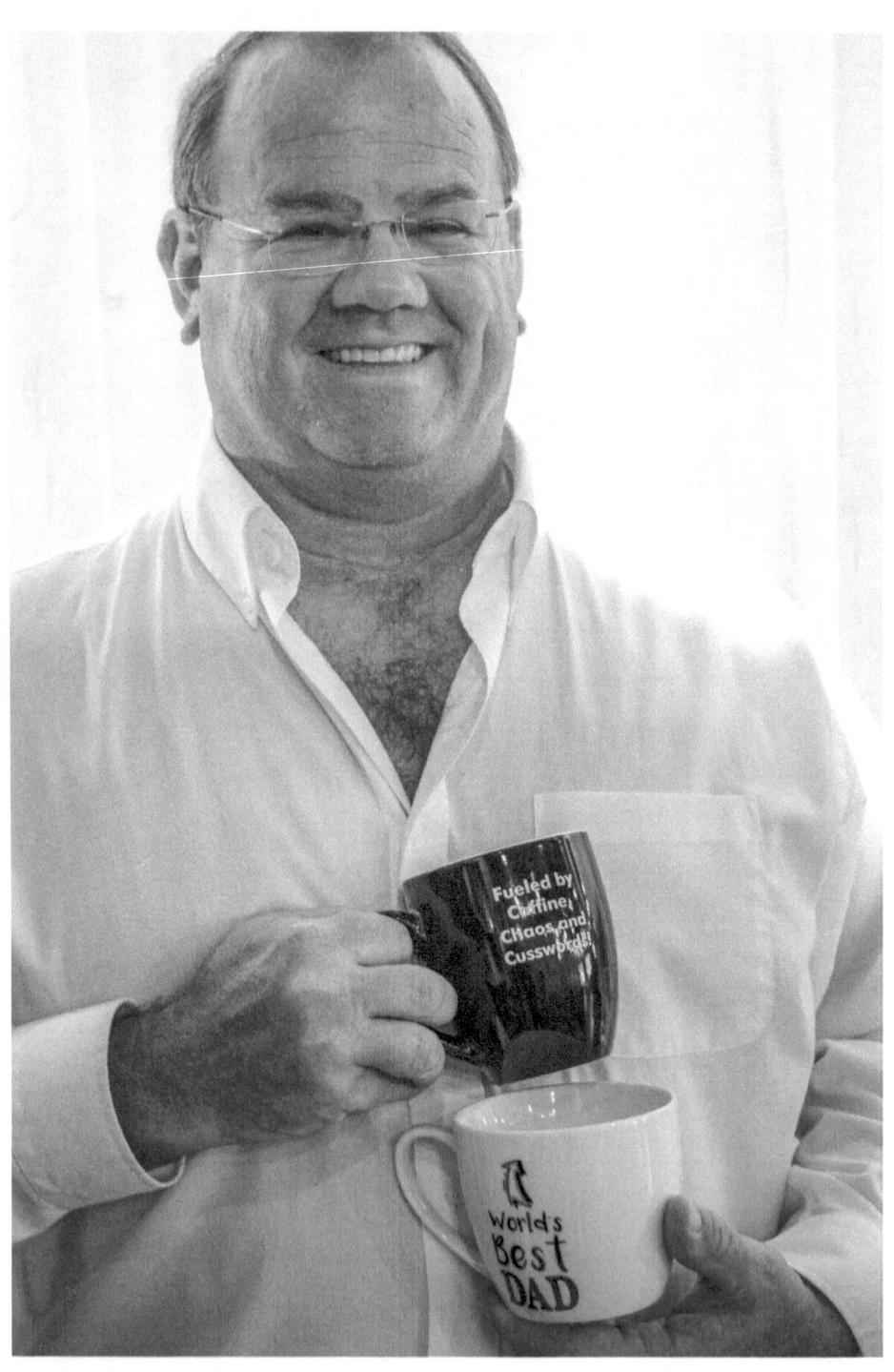

"DADS NEED THEIR COFFEE" @jojoscoffeeandgoodness ©2019 JIM CLARK

HOW DO YOU DRINK YOUR COFFEE?
are you a just black or some cream or a little bit of sugar, and
a single ice cube or does it have to taste like hot chocolate?
who would you like to share a cup of coffee with?

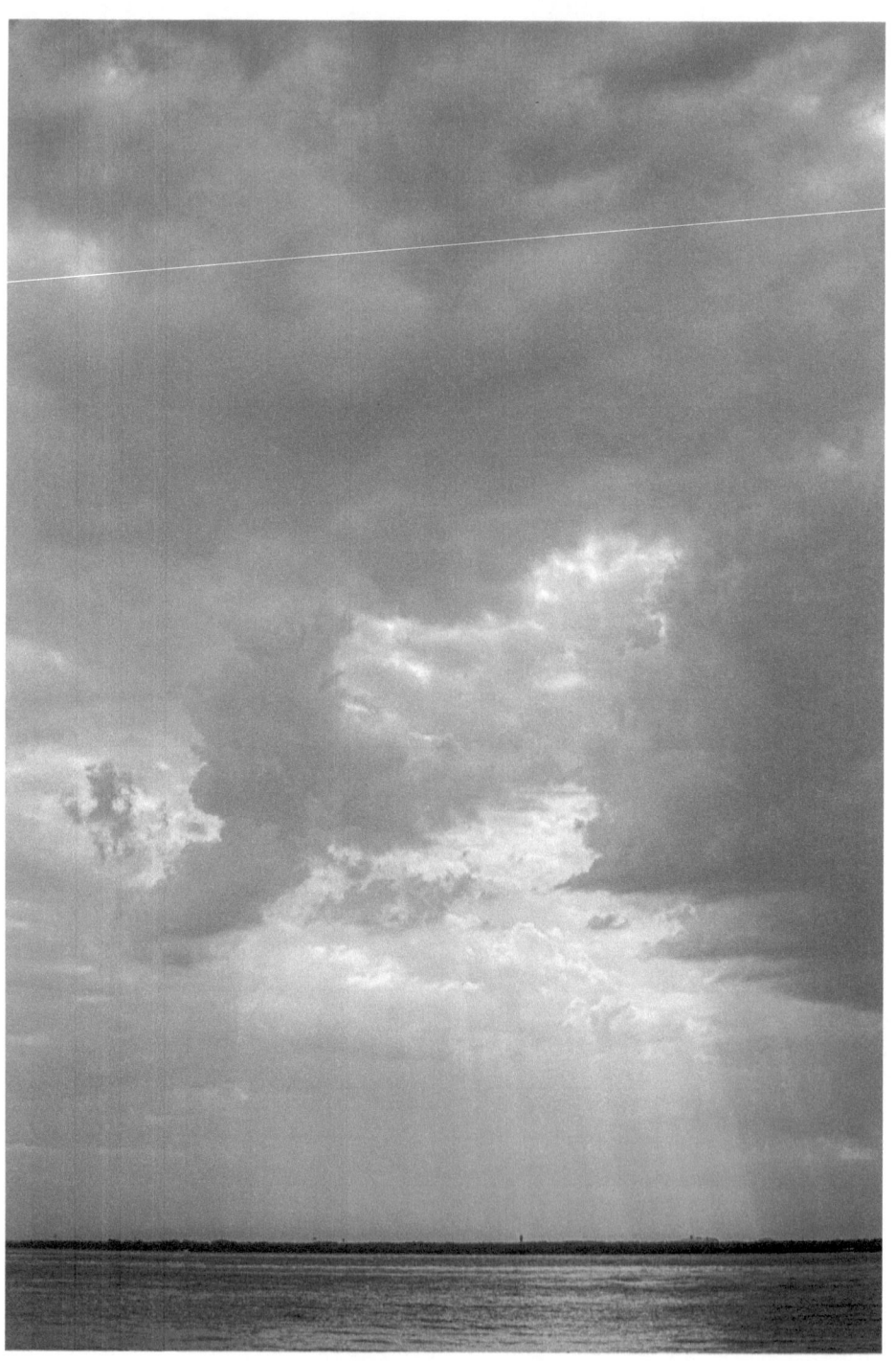

"DEEP THOUGHTS" ©2019 JIM CLARK

IF THIS WAS YOUR LAST SUNSET...
what would you do? who would you say goodbye to?

another day in Niceville

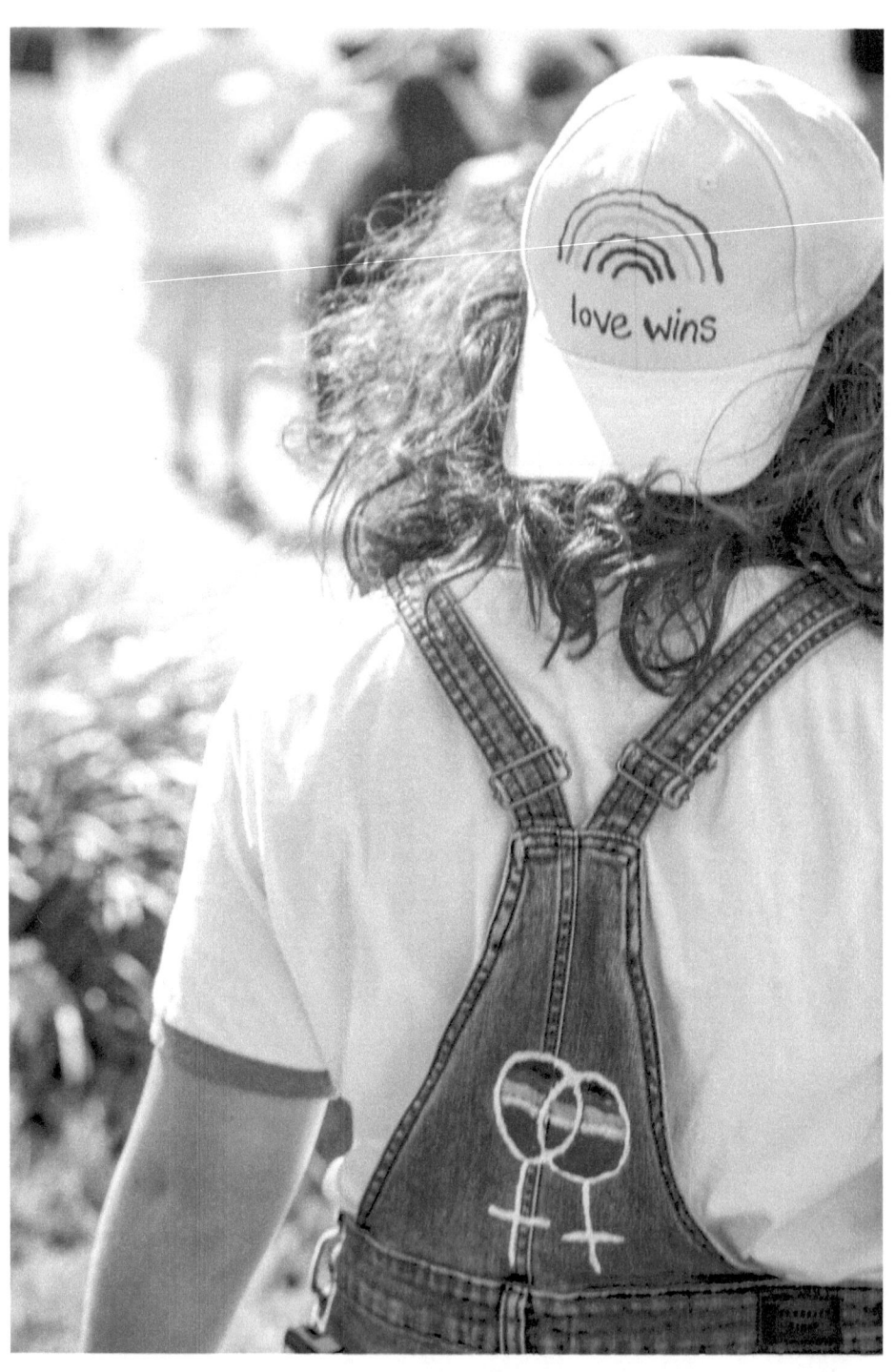

"ALWAYS AND FOREVER..." @pride

©2019 JIM CLARK

WHERE IS YOUR LIFE LEADING YOU?
describe your path and how you feel about your journey

another day in Niceville

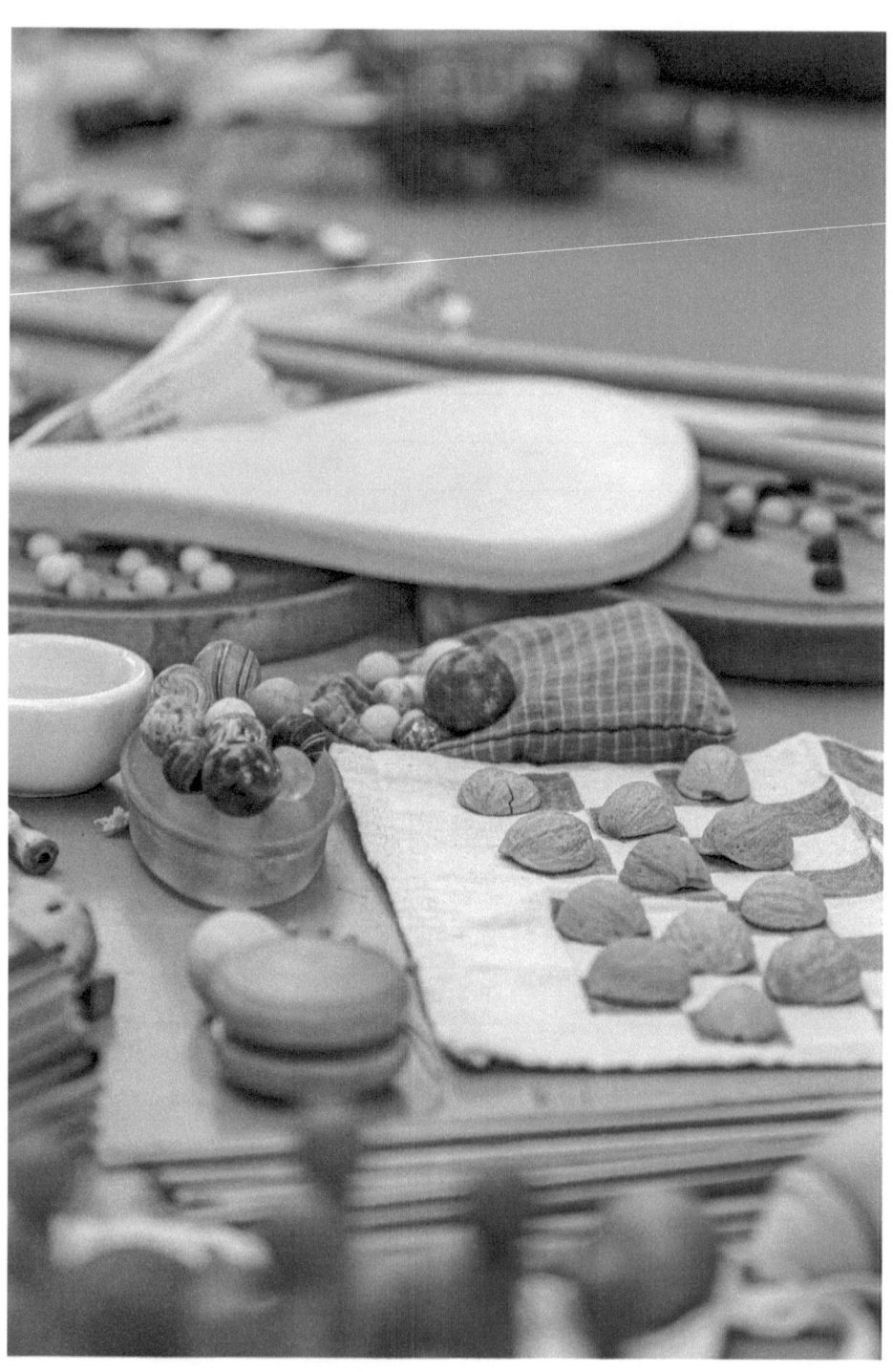

"GAMES FROM THE PAST"

©2019 JIM CLARK

WHAT'S YOUR FAVORITE BOARD GAME?
I know you must have played fun games as a child, with your family or friends. did you always win or did it matter as long as you got to play?

did you play games outside? what were they called?

draw and play tic-tac-toe below

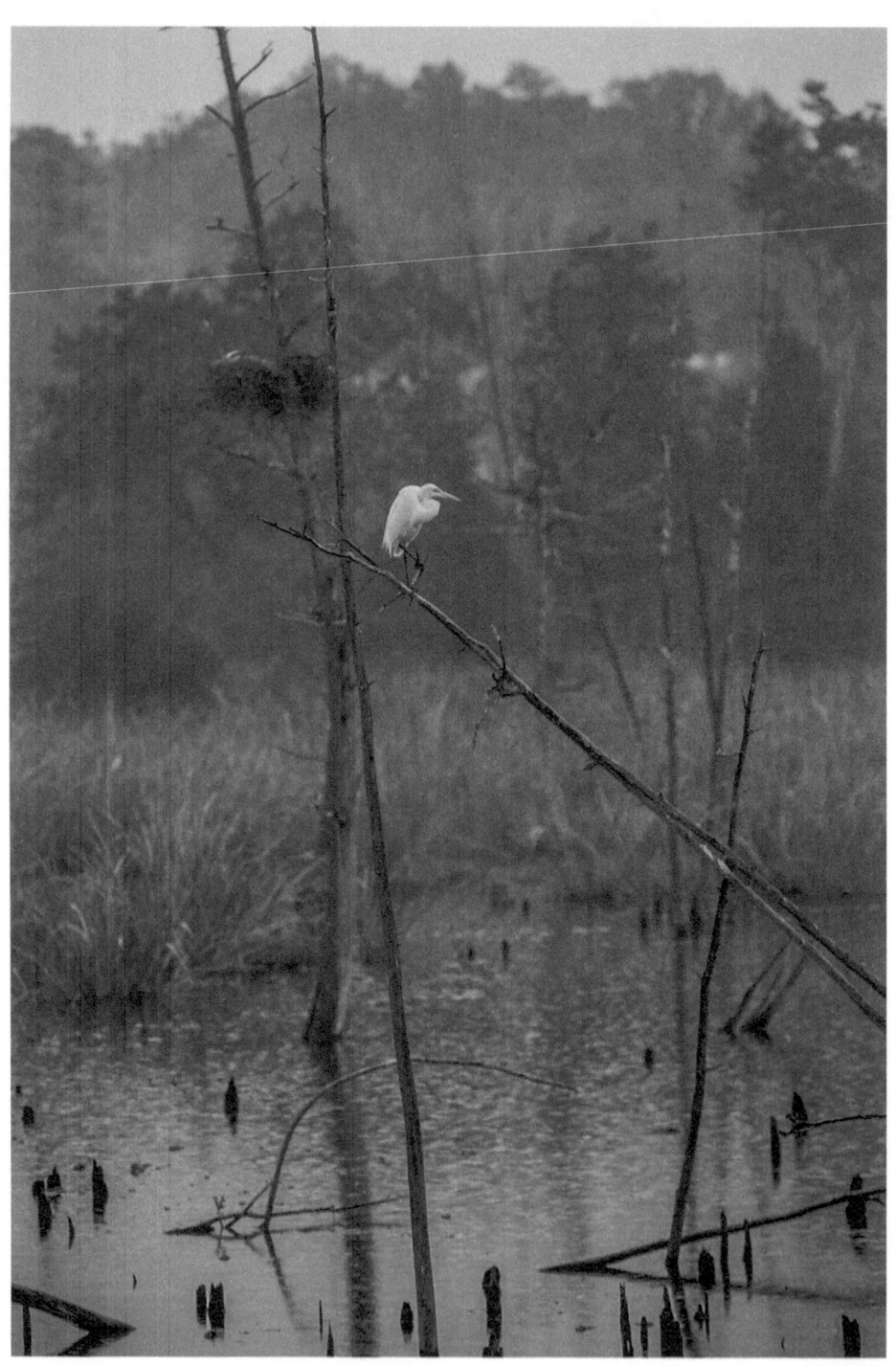

"ALONE TIME"

©2019 JIM CLARK

DO YOU LIKE TO SPEND TIME ALONE?
where do you go for alone time? what or who do you find yourself thinking about when you're taking time for you? share it here...

another day in Niceville

"A SHORT STORY"

©2019 JIM CLARK

TO BE A KID AGAIN
what did you like to do for fun as a child? do you still do it today?
did you wear fun clothes? write it down

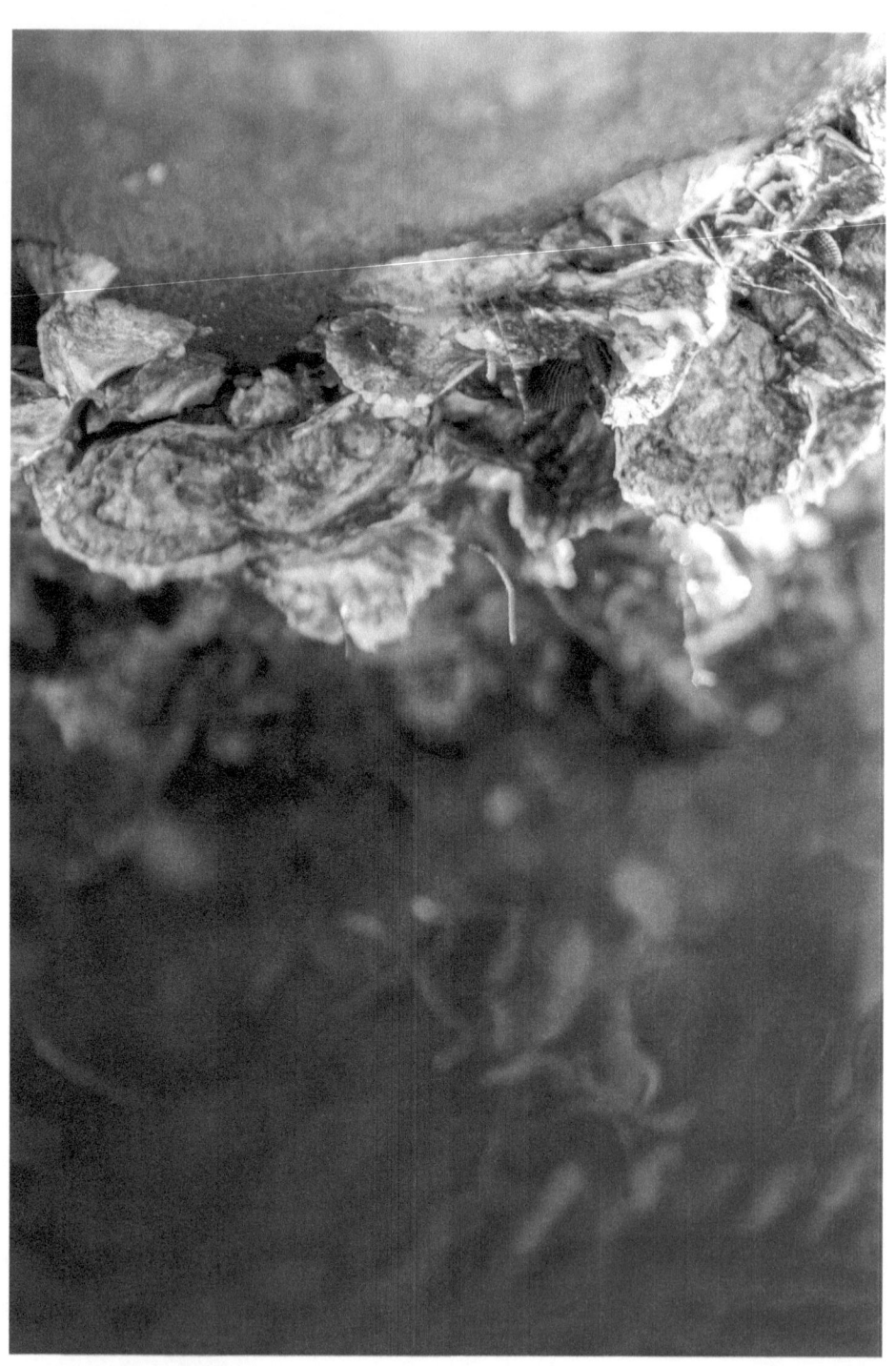

"OYSTERS ON THE PYLON" ©2019 JIM CLARK

WHAT GROWS ON YOU?
is there something or someone who has grown on you? you may not have cared for them at first but now you couldn't live without them.

DRAW AN OYSTER
use dots, lines, or whatever you feel like using then color it if you want to.
draw one in the water, on the shore or on the half shell.
don't forget the pearl either.

another day in Niceville

"FACETIME"

©2019 JIM CLARK

WHAT TYPE OF PEOPLE DO YOU HAVE AROUND YOU IN YOUR LIFE?

grumpy, happy, negative, positive, sad, disgusting, or motivating?
why do have them in it?

draw faces or an emoji... sad, mad, silly, crazy, smiling, frowning, and more and make the face too

another day in Niceville

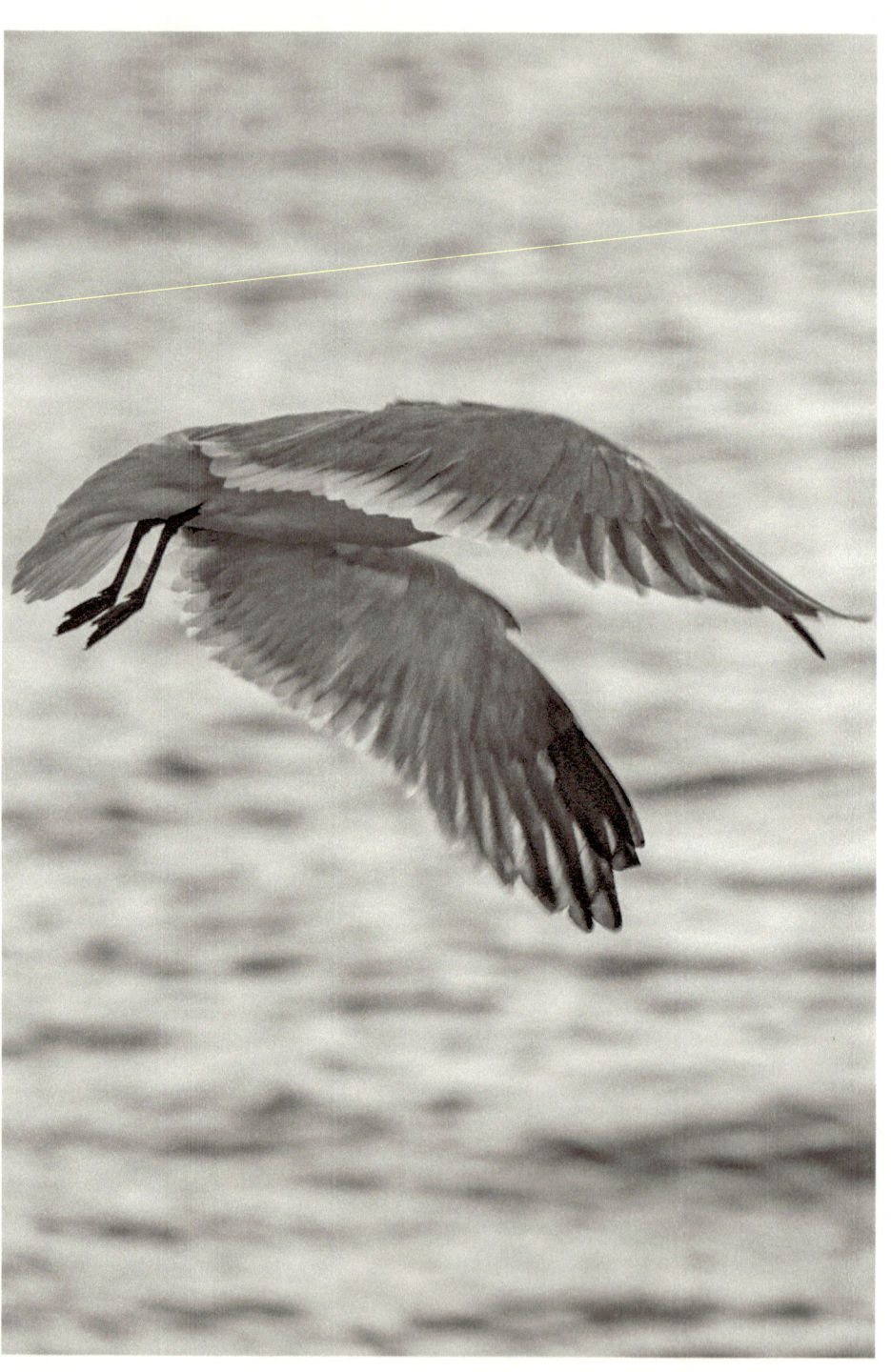

"TAKING FLIGHT" ©2019 JIM CLARK

WHAT KEEPS YOU GROUNDED?
your family, friends, faith or something else

if you were a bird, what kind of bird would you be and why?

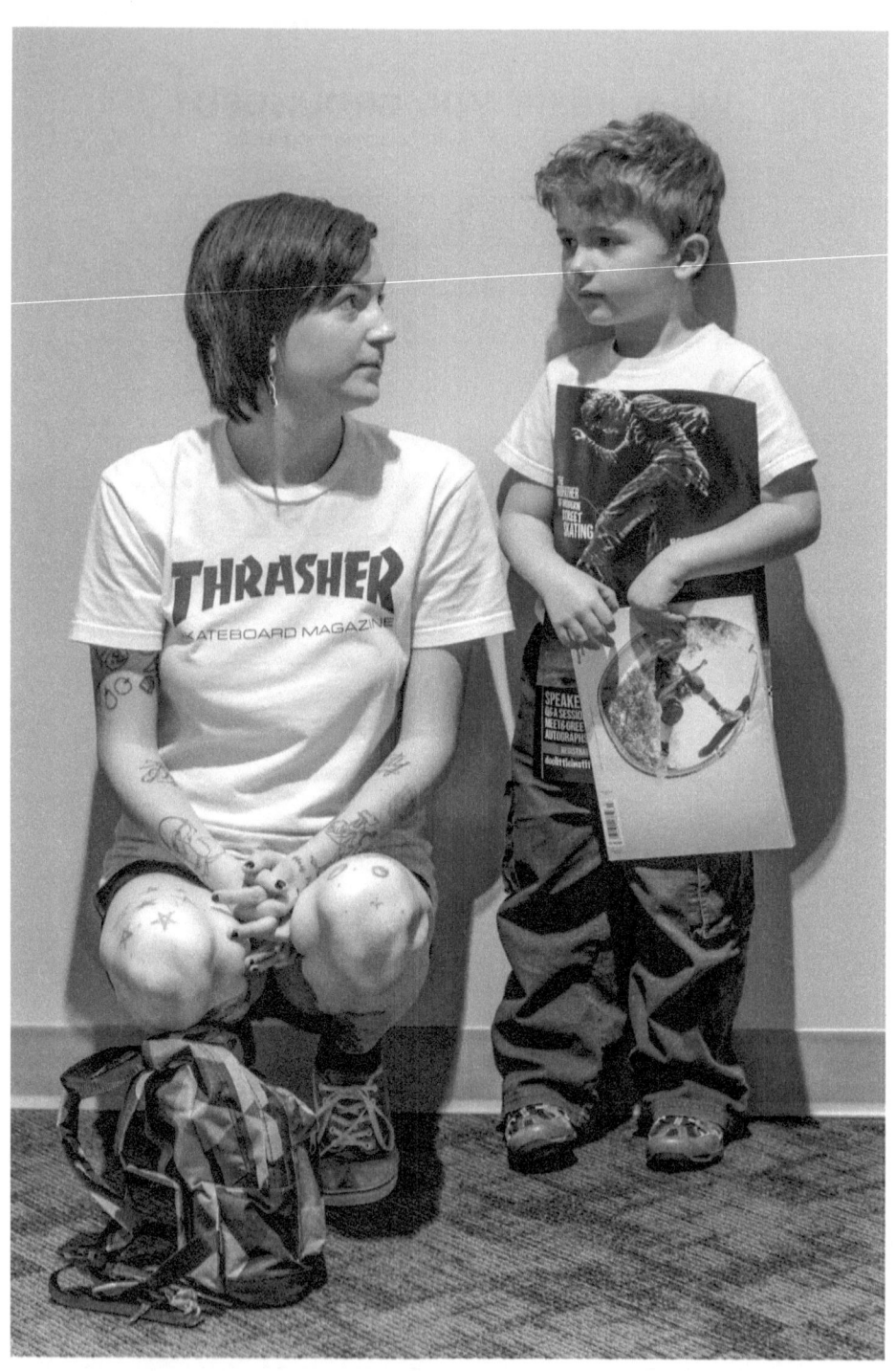

"LEARNING PATIENCE" @brackenmyday ©2019 JIM CLARK

WRITE SOME OF THE THINGS YOUR MOM OR DAD HAS TAUGHT YOU IN LIFE

did you use what they taught you? did you teach or share this lesson to someone else? do you think they will use and share it too?

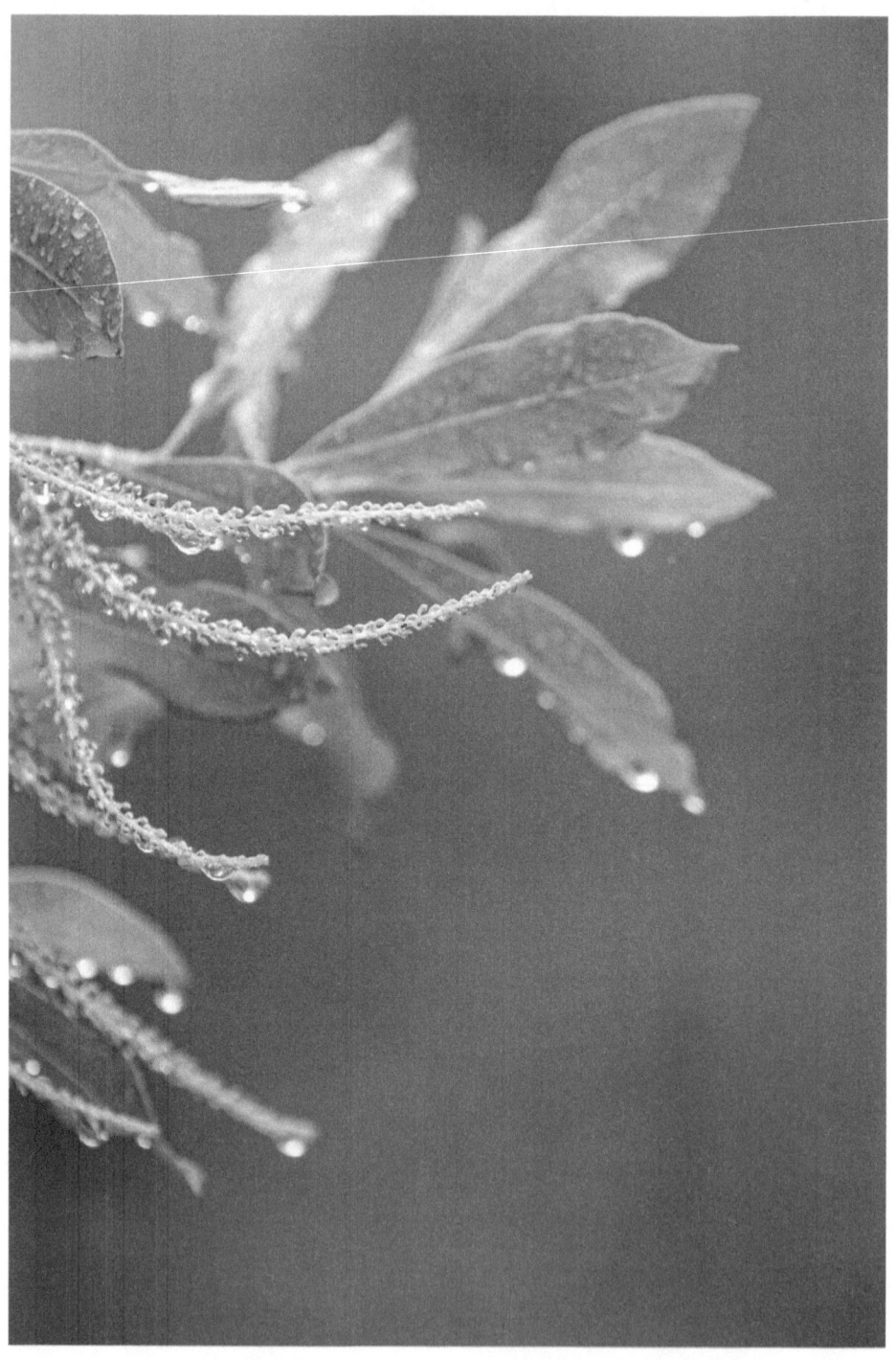

"FEELS CHILLY" ©2019 JIM CLARK

WHERE DO YOU GO FOR THE WINTER?

Niceville may be our home but we do get winter visitors. if you are one of them, where did you go while here? if you didn't come here, where do you like to go during winter?

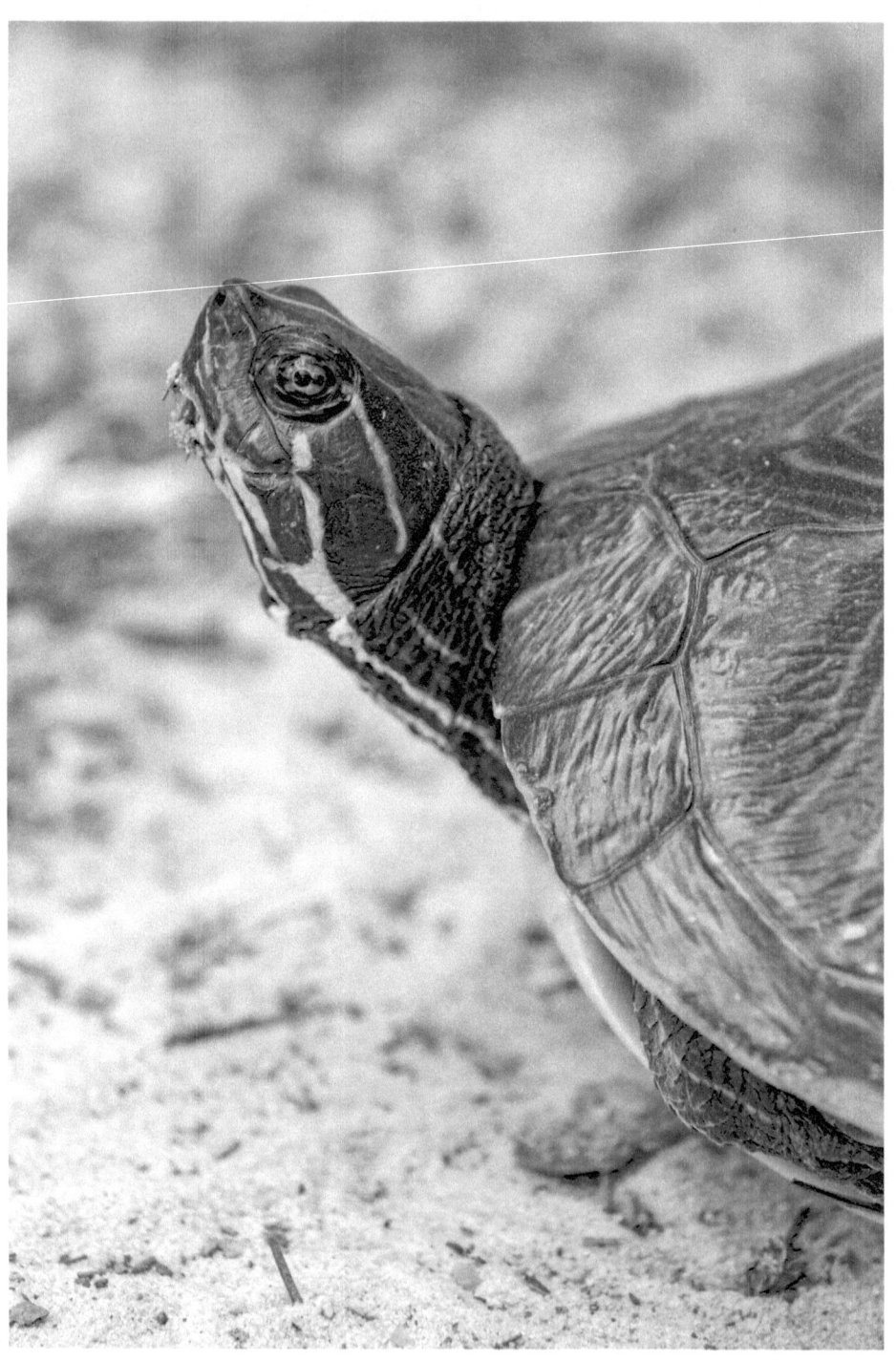

"BOX TURTLE"

©2019 JIM CLARK

DO YOU HAVE A PET?

what kind of pet? what is its name? what does it like to play with?
did you have it as a child or as an adult?

what was the strangest pet you have ever seen or heard of?

another day in Niceville

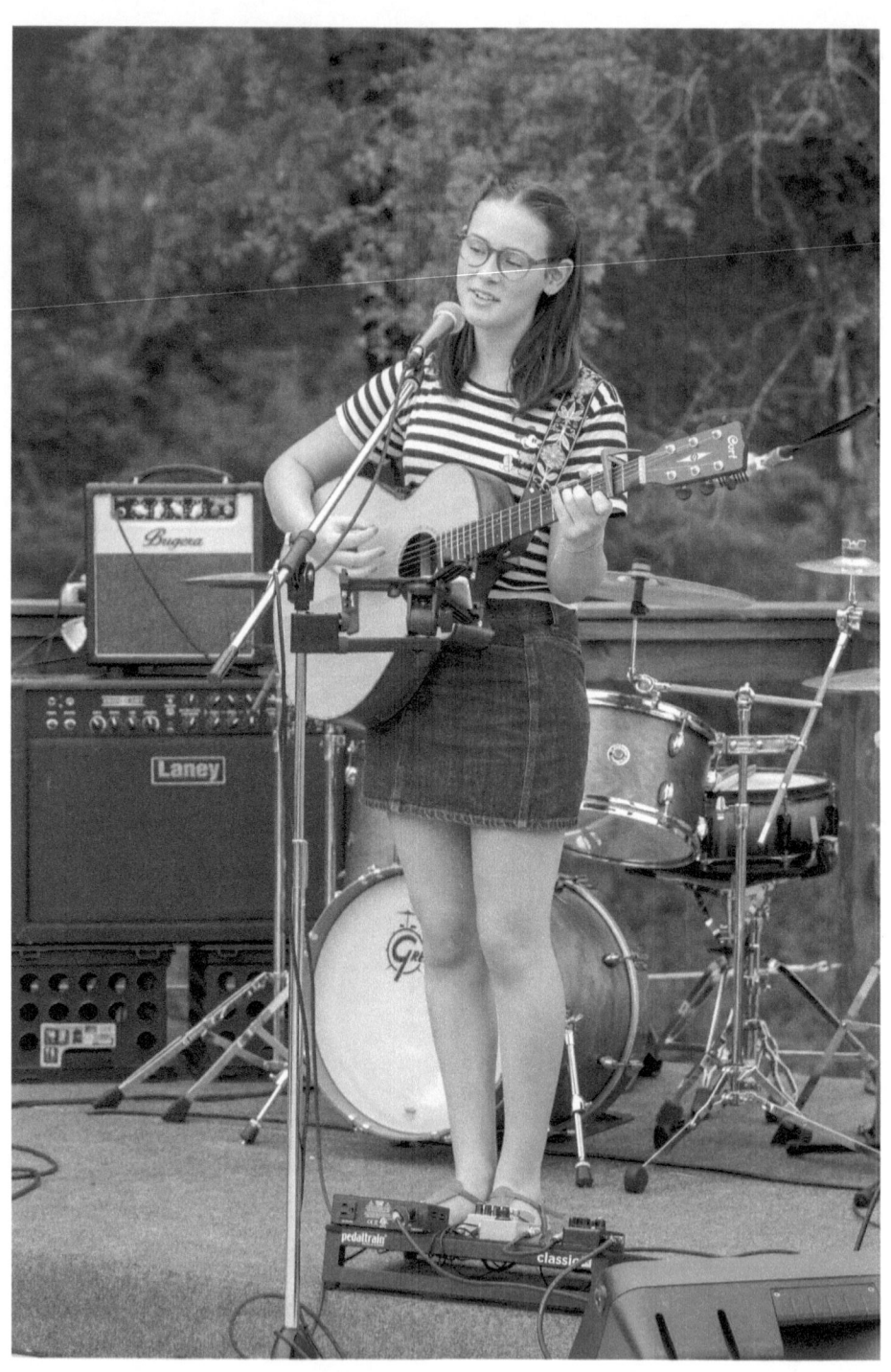

WHAT MAKES YOU CRY?

watching talented people sing has made me tear up before, emotional and romantic movies get me to cry too. write your tearjerkers below:

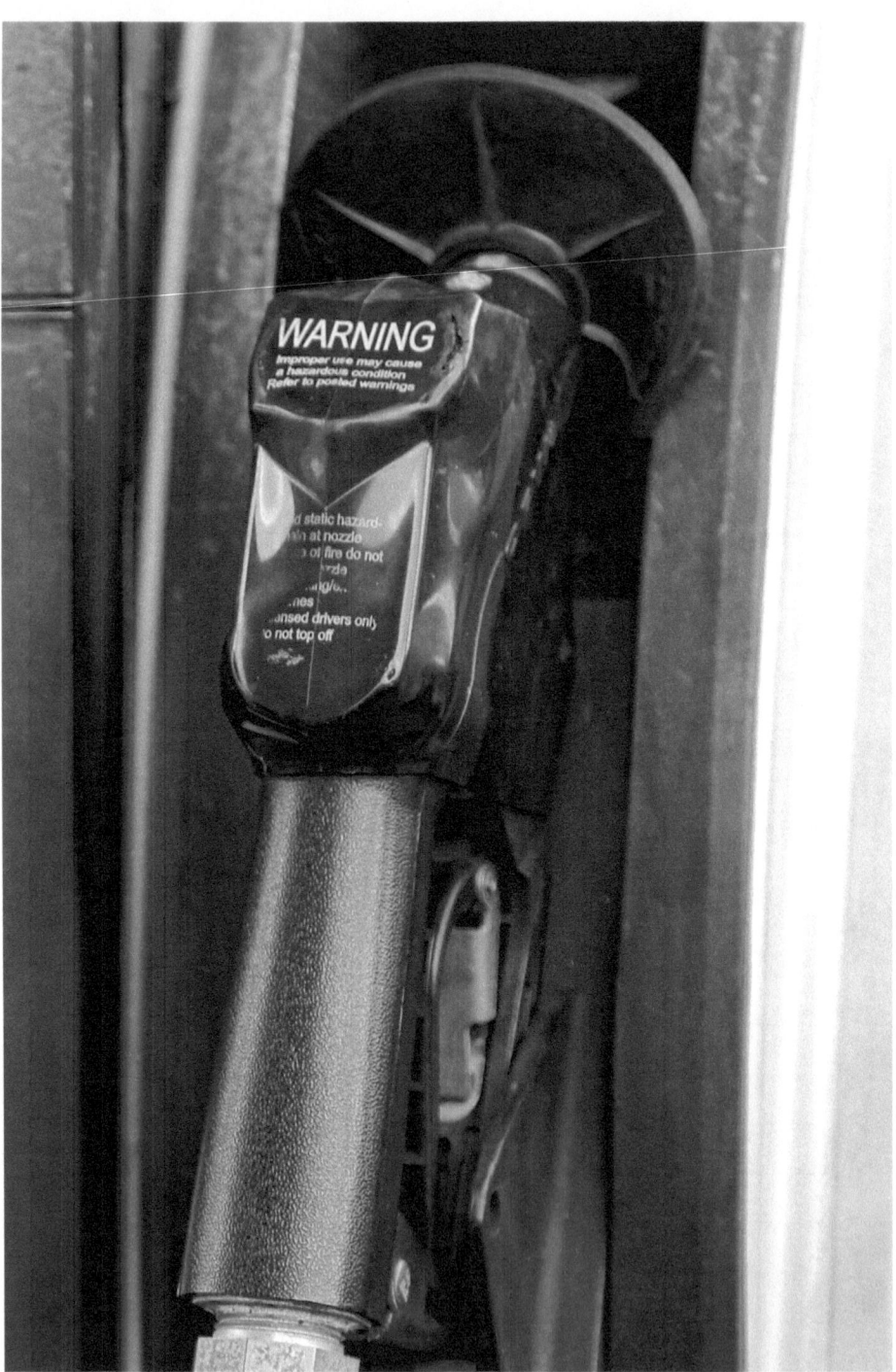

"FILL IT UP" ©2019 JIM CLARK

HAVE YOU EVER RAN OUT OF GAS?
most of us have at one time or another and the last time I almost did I coaster into the gas station. tell us your out of gas story.

what is the cheapest price per gallon you can remember buying gas? where did you live when you bought the gasoline and what type of car did you have to drive?

another day in Niceville

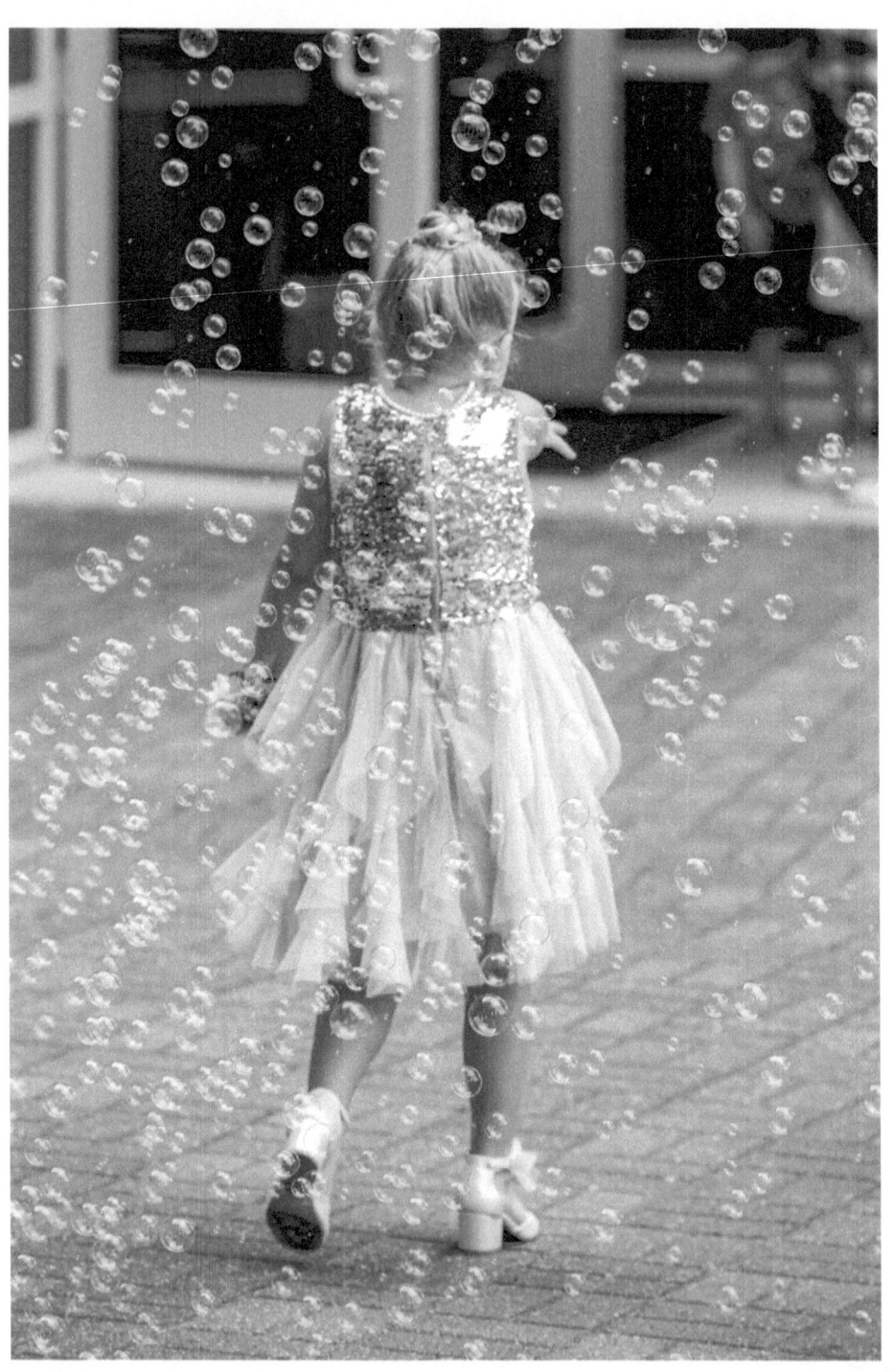

"BUBBLES, BUBBLES, BUBBLES!"

©2019 JIM CLARK

DO YOU LIKE BLOWING BUBBLES?

when was the first time you can remember doing it and who was there with you? do you like popping them or just letting them go into the sky to see how far they will float until they pop?

draw some bubbles in the space below

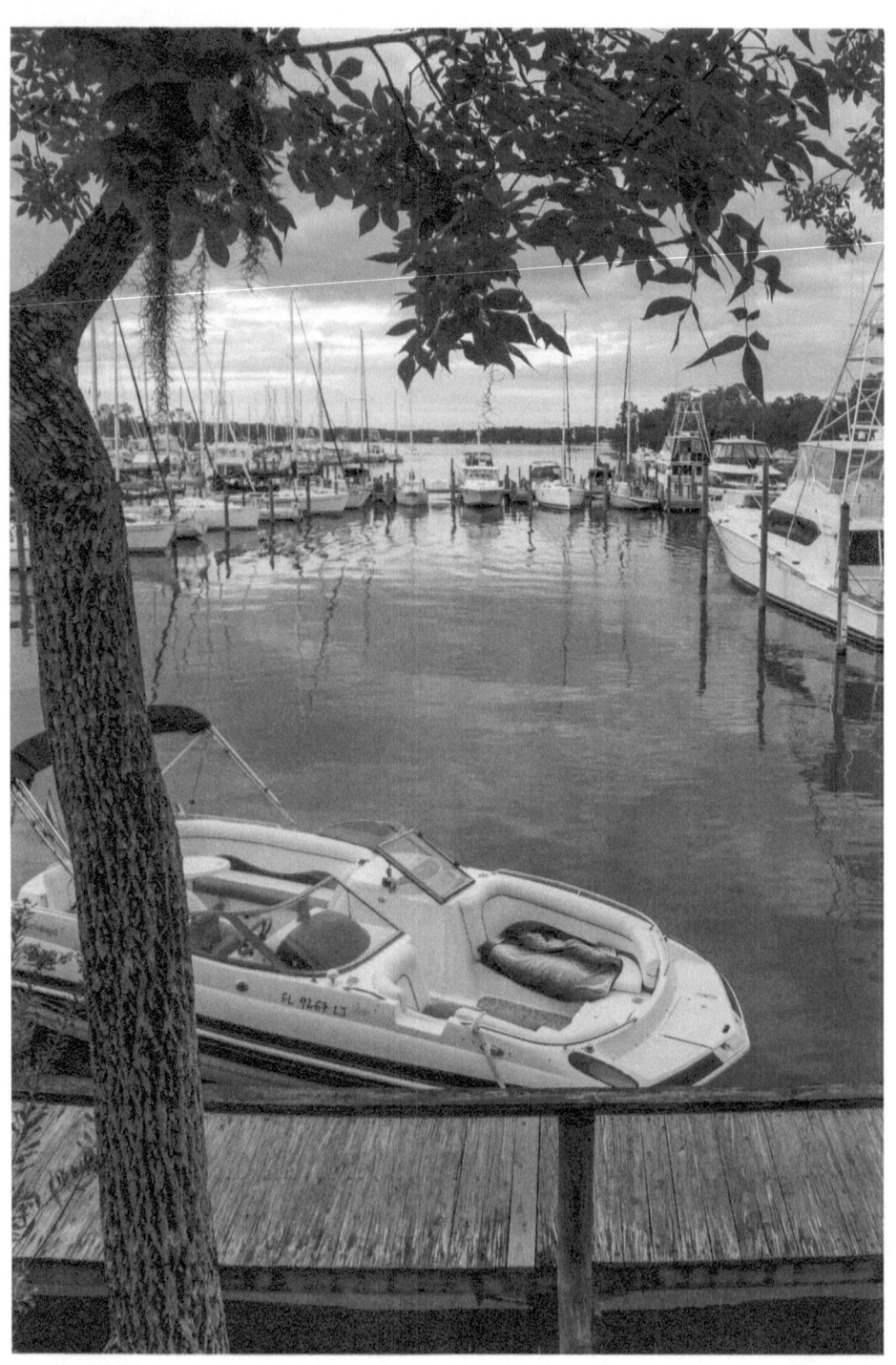

"DAYTRIPPING" ©2019 JIM CLARK

WHERE DO YOU GO FROM HERE?

what trips are you looking forward to? write down your exotic travel plans or a once in a lifetime vacation idea and list who you would take with you

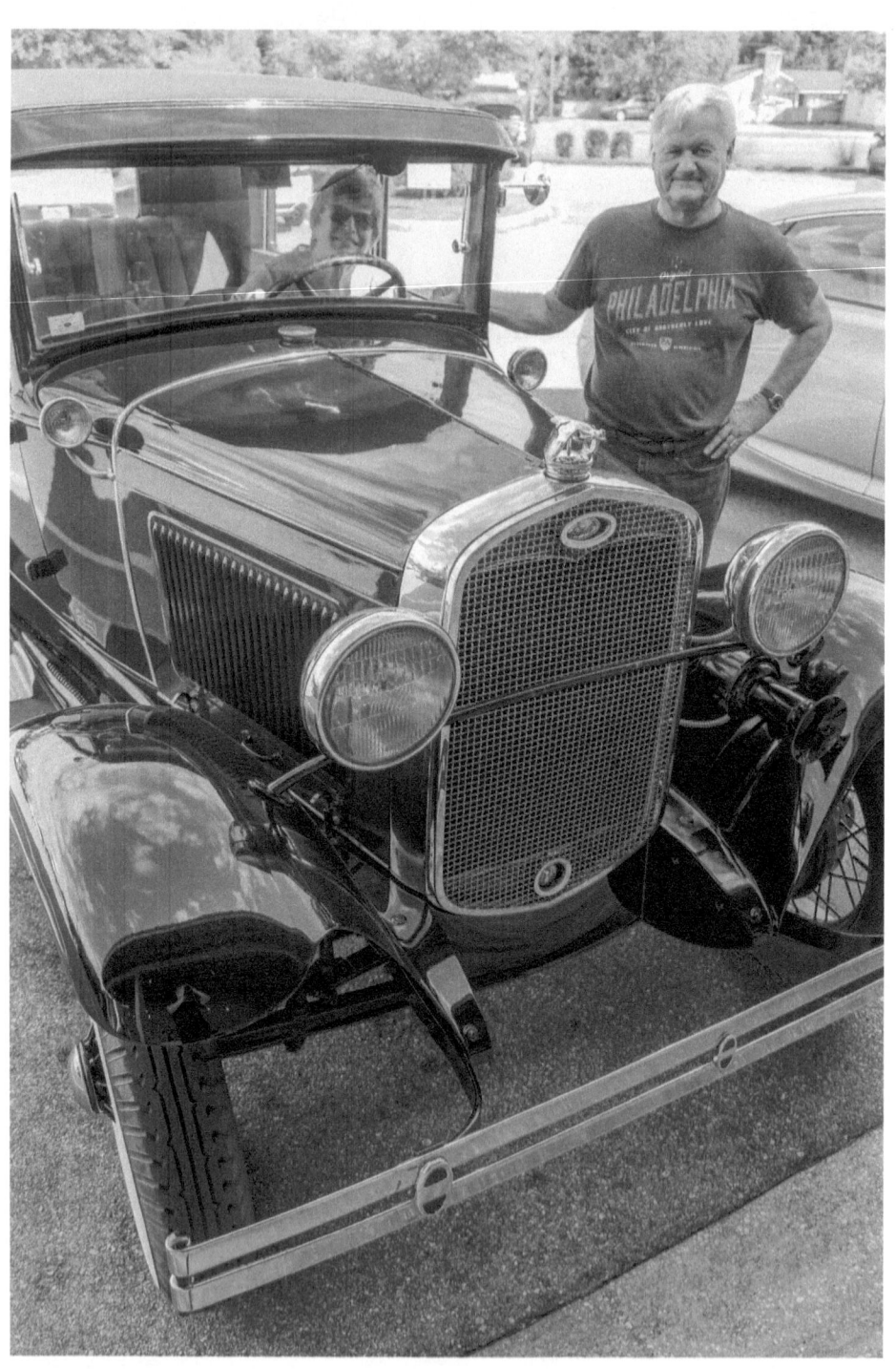

"ED AND AGGIE'S MODEL A" ©2019 JIM CLARK

WHAT WAS YOUR FIRST CAR?

a brand new beauty or a used one that used more oil than gas like mine?
I know that I loved mine because it got me from point a to point b.
share with us your first, second or your current car story below

what would you find inside your car or truck today?

"ANTICIPATION" ©2019 JIM CLARK

WHAT ARE YOU WAITING FOR IN LIFE?

a chance to dance, that special someone, love, a story to tell, a new job, or something completely different? write it down here:

visualize it and then make it happen

write down three goals of yours here:

ask a friend their goals and put them here:

another day in Niceville

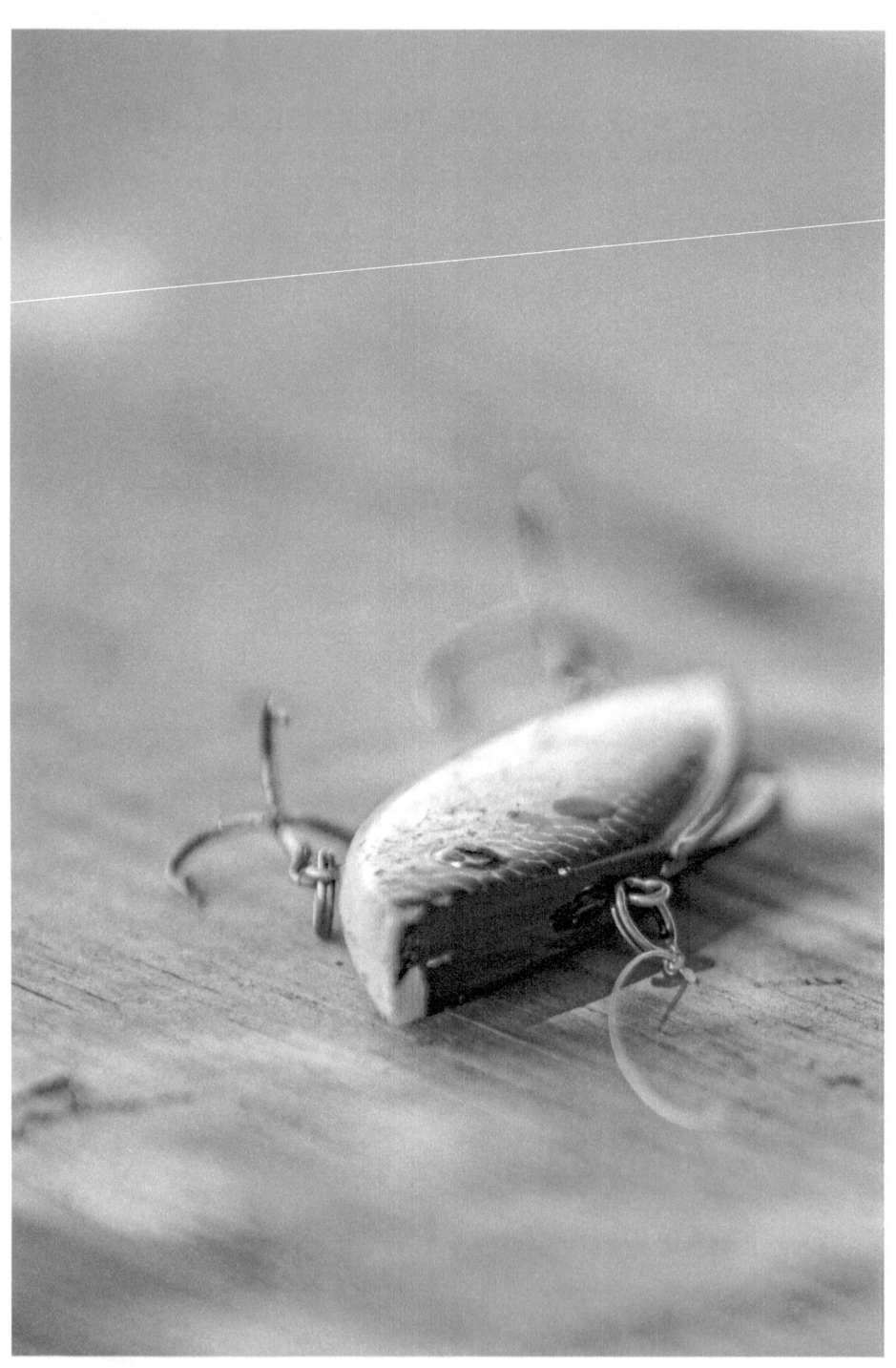

"AN ALLURING LURE"

©2019 JIM CLARK

DO YOU LIKE TO GO FISHING?

do you like going alone or with a group? what was the biggest fish you have ever caught and what did it taste like? what did you use for bait?

draw a picture of a fish

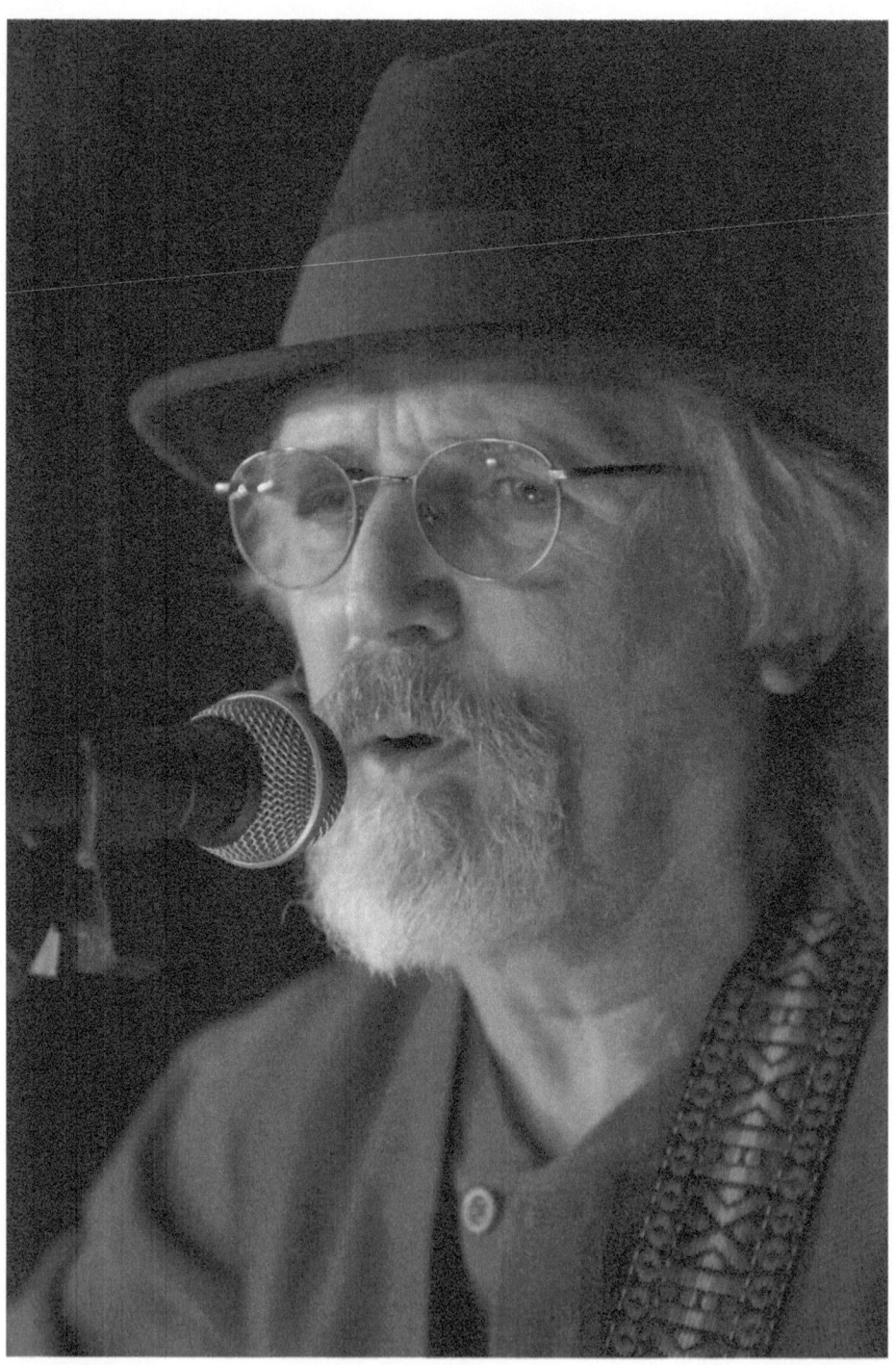

HAVE YOU EVER WRITTEN A SONG?
what would be the title of your new song be? write your song here.
it doesn't have to rhyme and it only takes a little time.

another day in Niceville

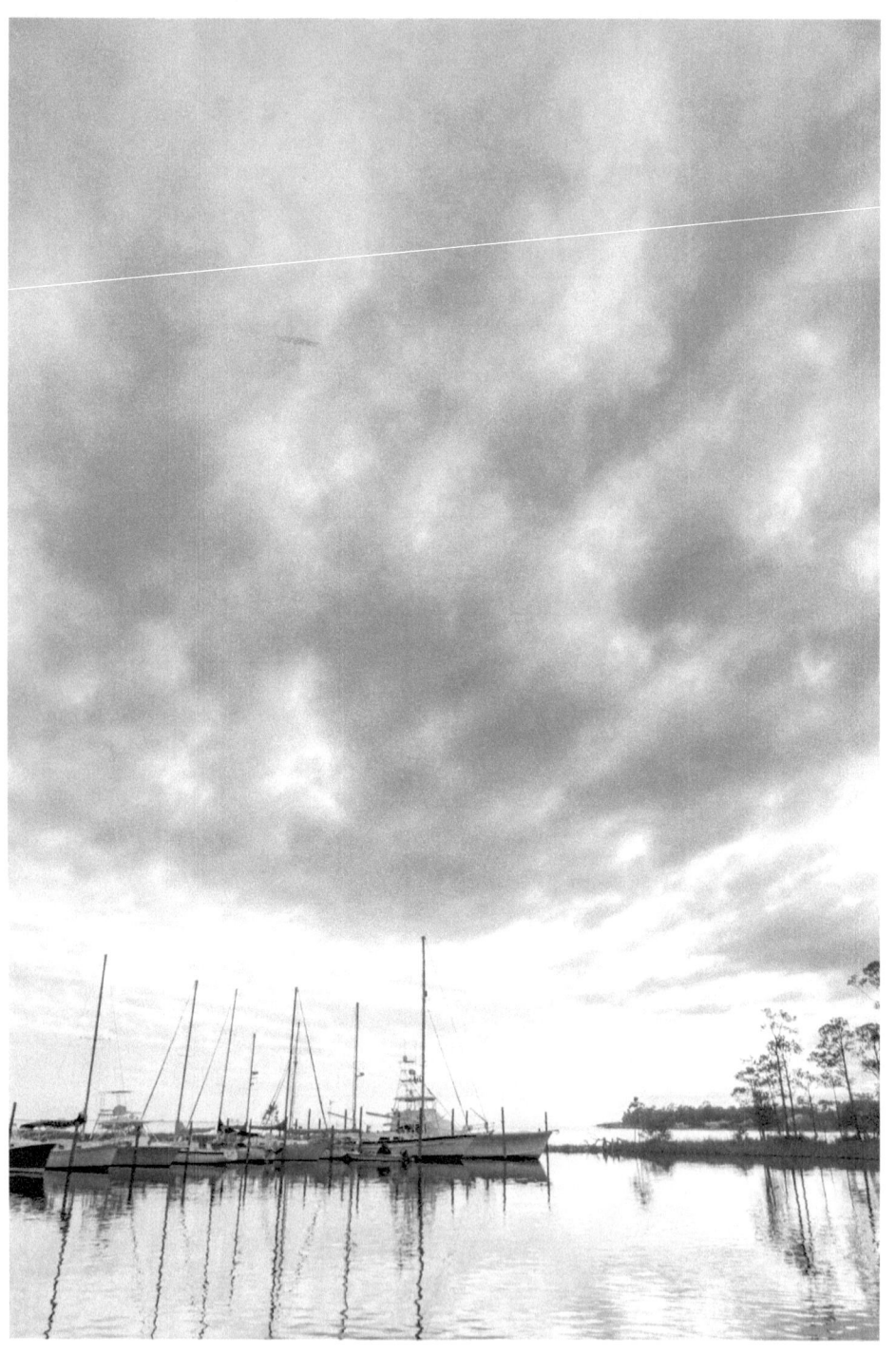

"I SEE IT... REALLY I DO"

©2019 JIM CLARK

THINGS ARE LOOKING UP

look into the sky and see if you see any clouds. if you do, what shapes are they in? if you don't, look at the photo on the left and write what you see in those clouds. draw on the photo to make the shapes

another day in Niceville

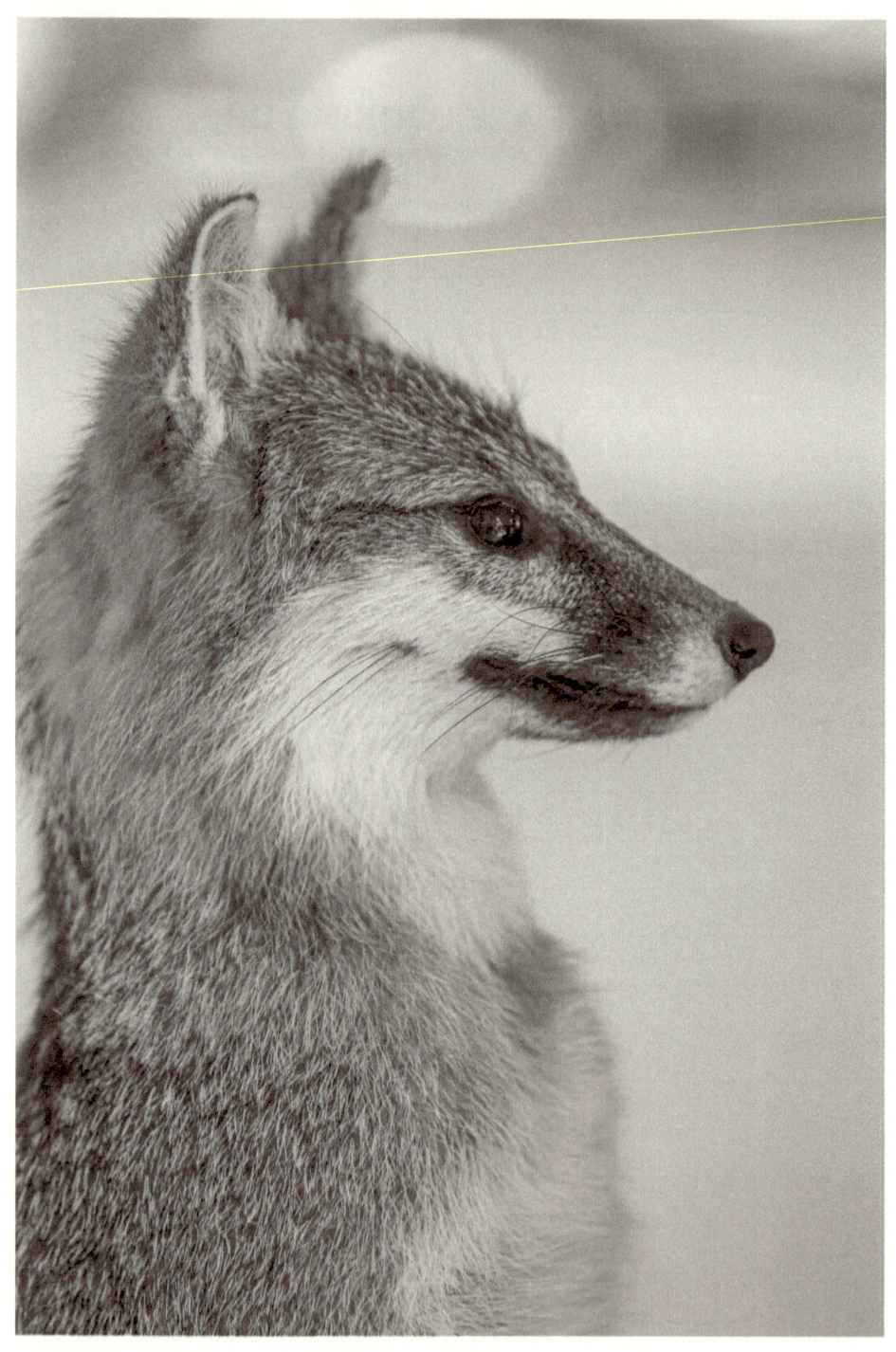

"I SEE A FOX"

©2019 JIM CLARK

WHAT ANIMALS HAVE YOU SEEN IN THE WILD OR IN YOUR NEIGHBORHOOD?

write them down below so you will always remember.
what wild animals would you like to see that you have not seen yet?

draw an animal... you can do it

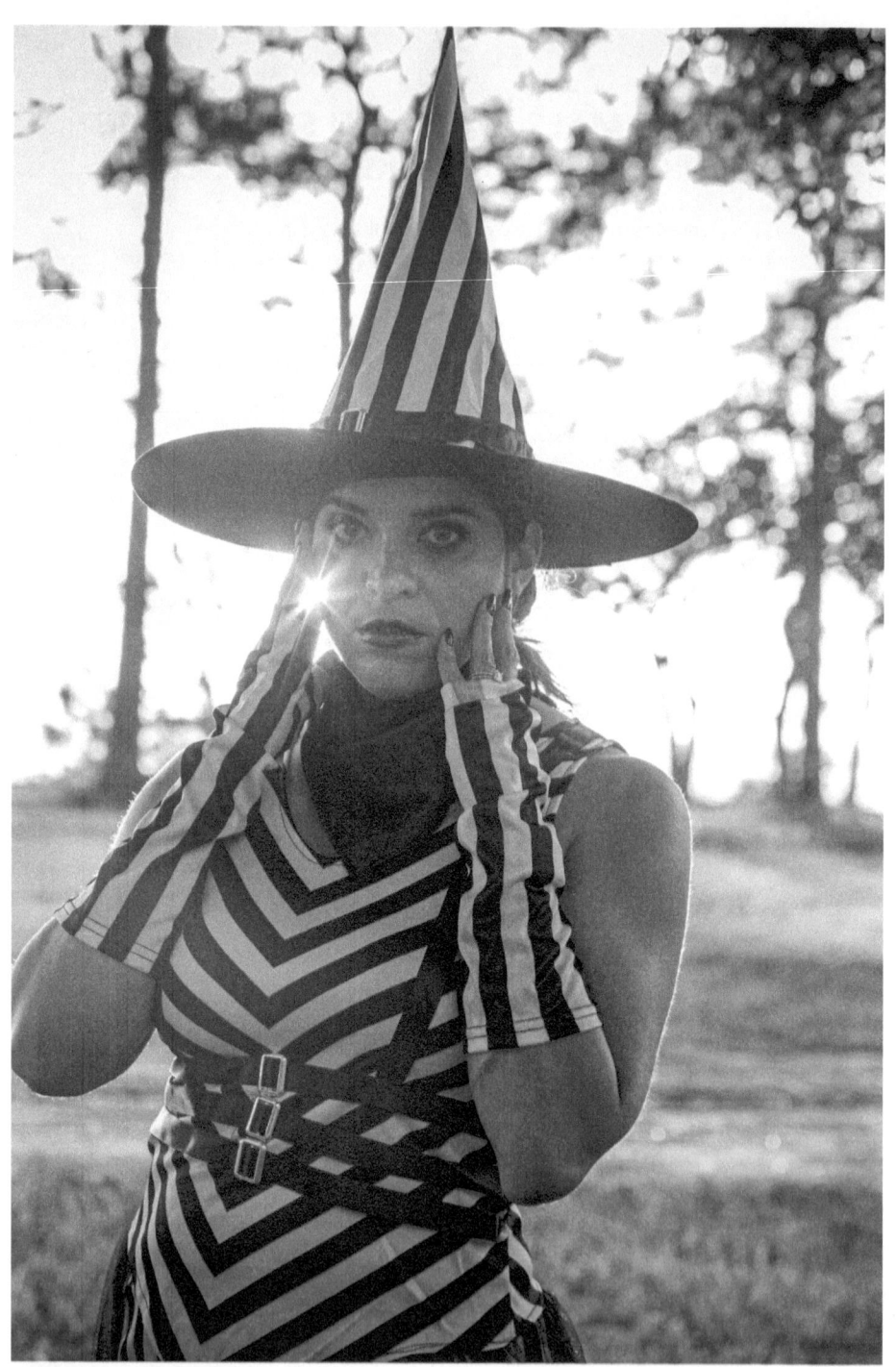

"DON'T LOOK INTO HER EYES"

©2019 JIM CLARK

WHAT ARE YOUR SCARIEST, FAVORITE, OR CREATIVE HALLOWEEN COSTUMES?

what was it? what do you remember most about it?
did it scare the kids?

doddle some Halloween things

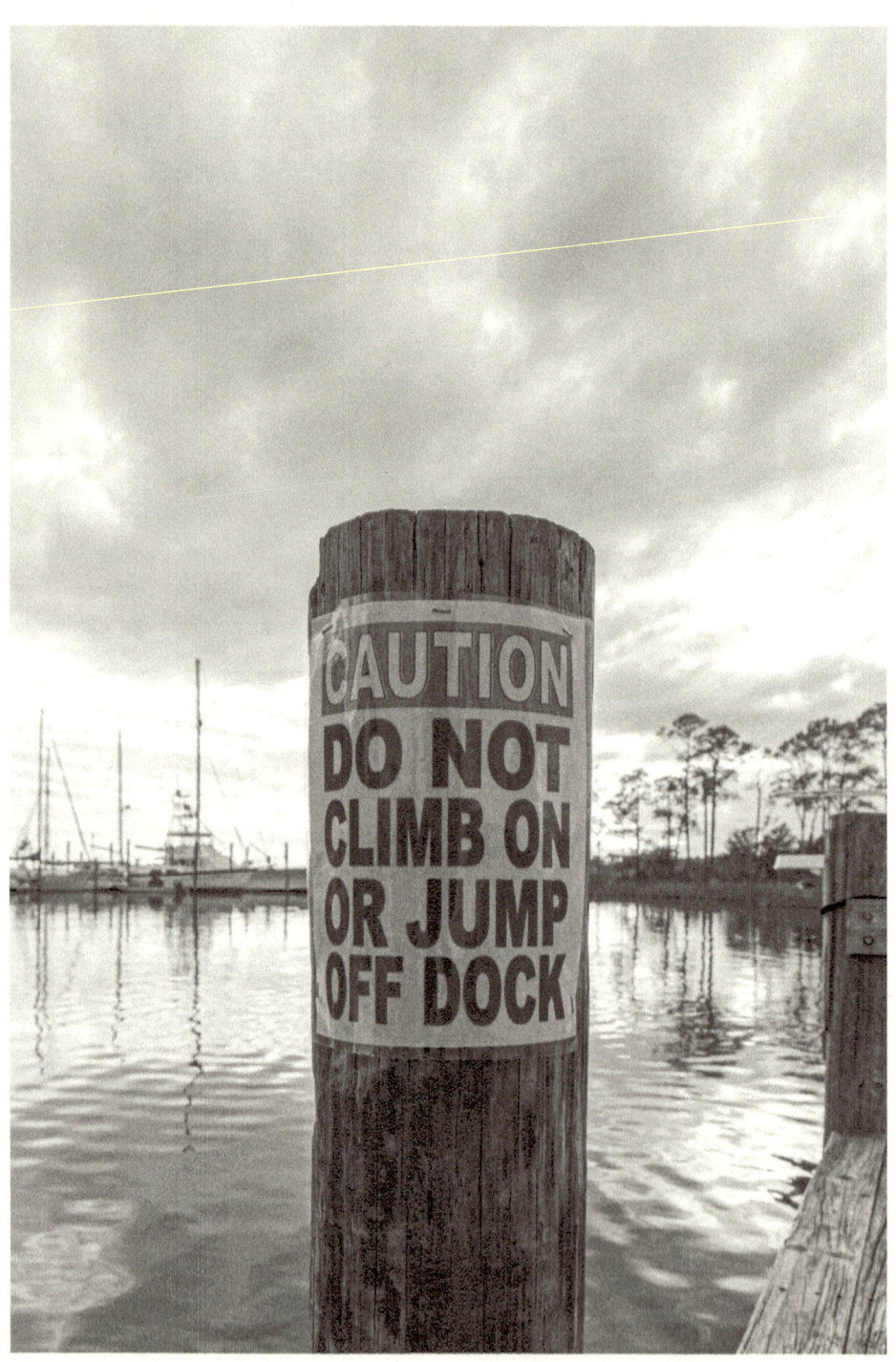

"CAUTION"

HAVE YOU EVER BROKEN THE RULES?
if yes, what did you do? if not, have you ever thought about doing it?
what did you do or think about doing? write your story here:

make up a rule for someone or something and write it here:

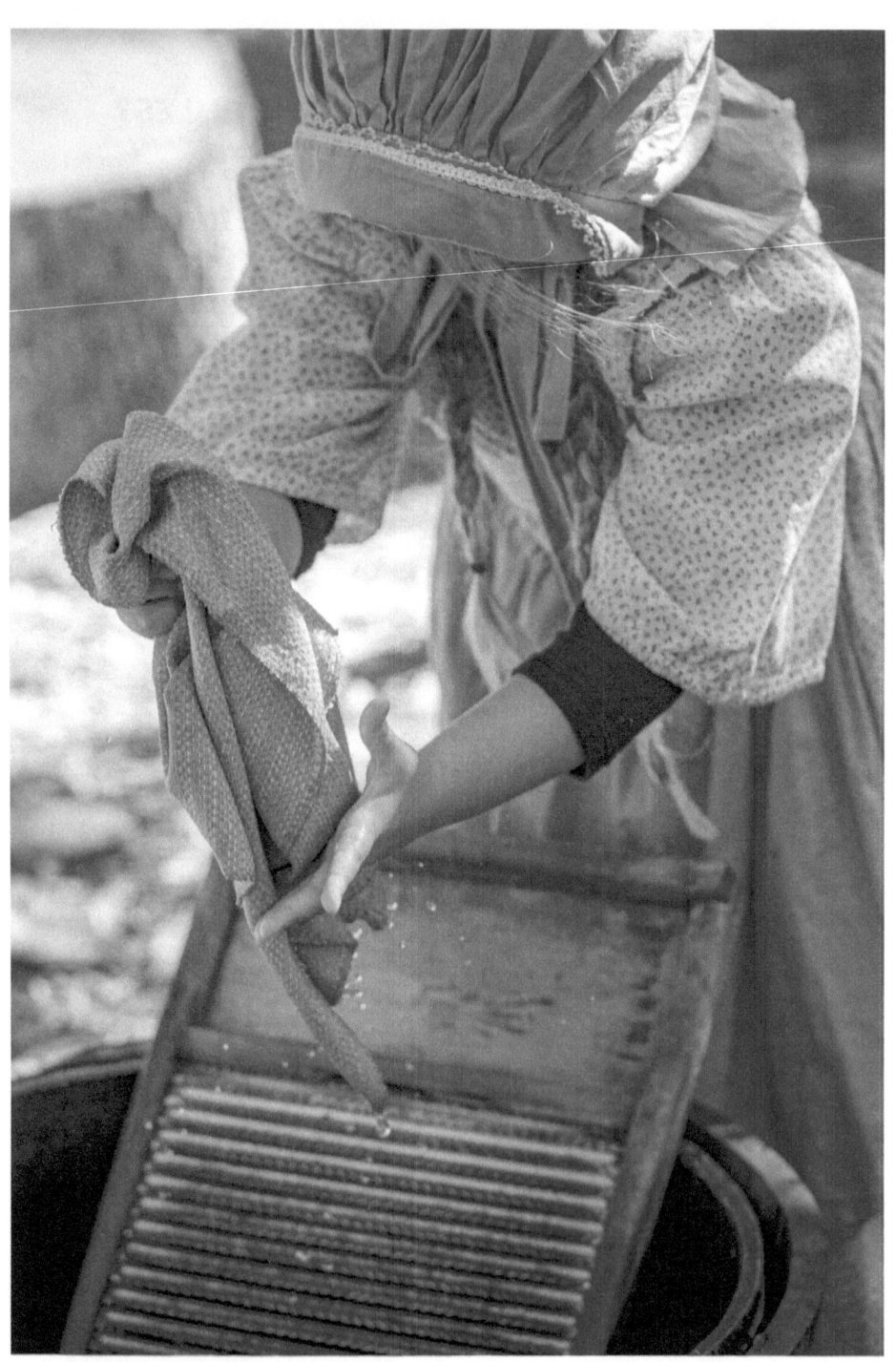

"PIONEER WASHING MACHINE"

©2019 JIM CLARK

WHO'S TURN TO WASH THE CLOTHES?
if you had to do it the old fashioned way, what would be your favorite part? getting the water, scrubbing, or hanging it out to dry?

draw some clothes hanging out to dry

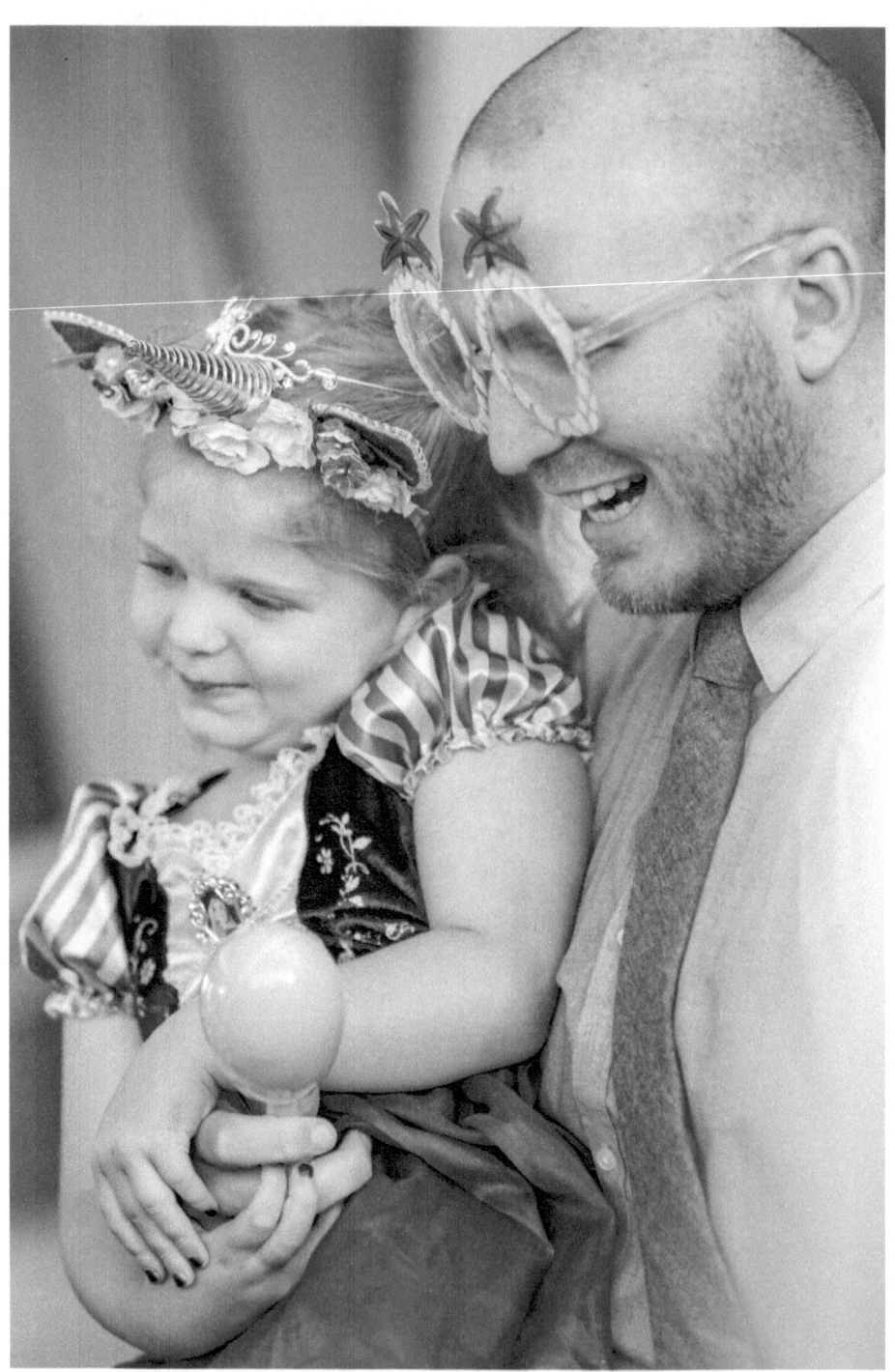

"TAKE OUR PICTURE"

©2019 JIM CLARK

DO YOU LIKE TO PLAY DRESS-UP?
does your dad or mom? what is the funniest thing you have seen them wear and why did they do it? did it make you or them smile?

draw below some fun items you could use for a fun selfie photo shoot or to act out a little story you just made up in your head

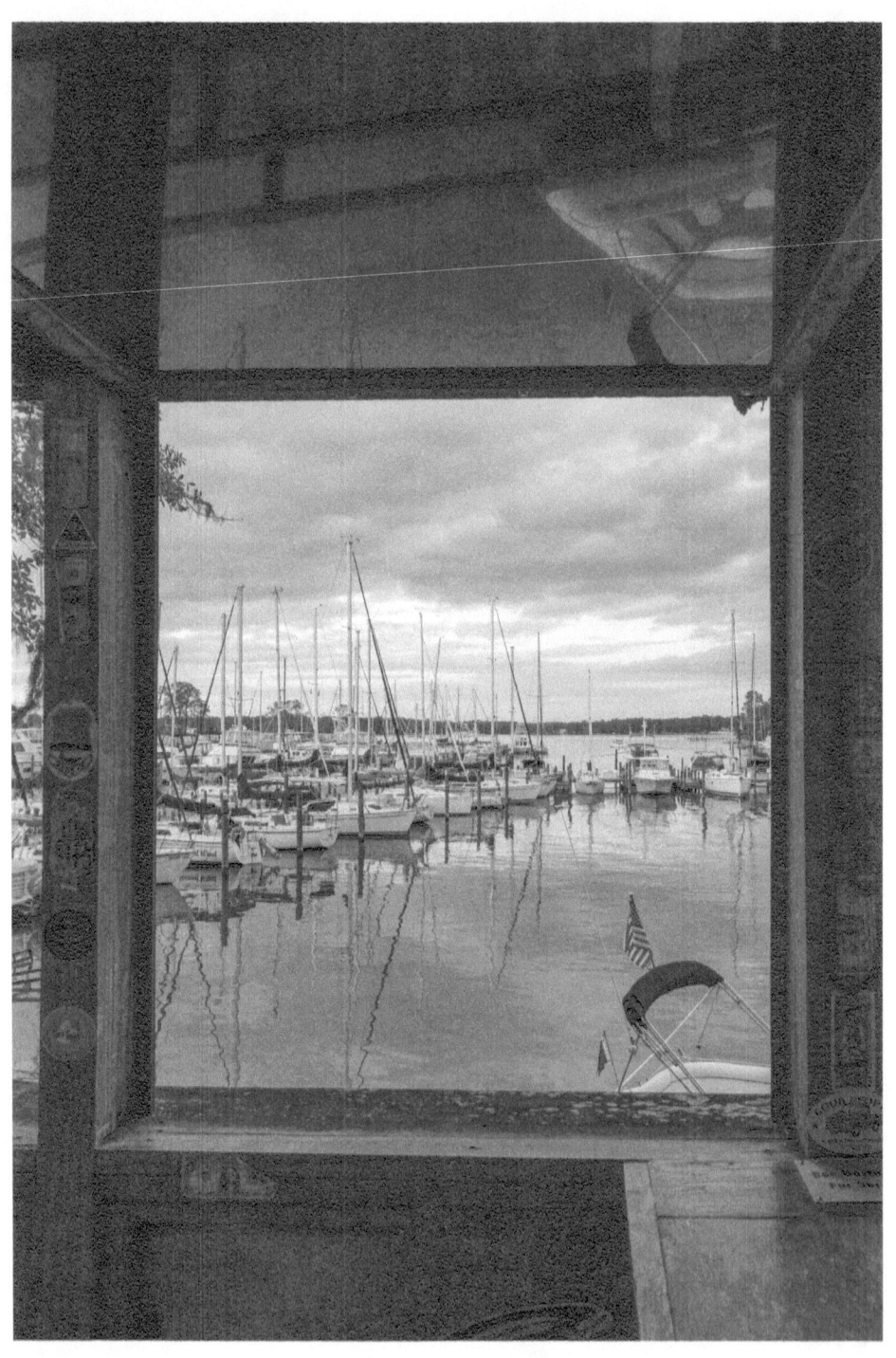

"A LOVE STORY"

©2019 JIM CLARK

WHERE DID YOU MEET YOUR FIRST LOVE AND WHAT IS YOUR STORY?

write one of your love stories here and include how it made you feel then and now. where you meet, what was their name and how long it last? now think about your first kiss

another day in Niceville

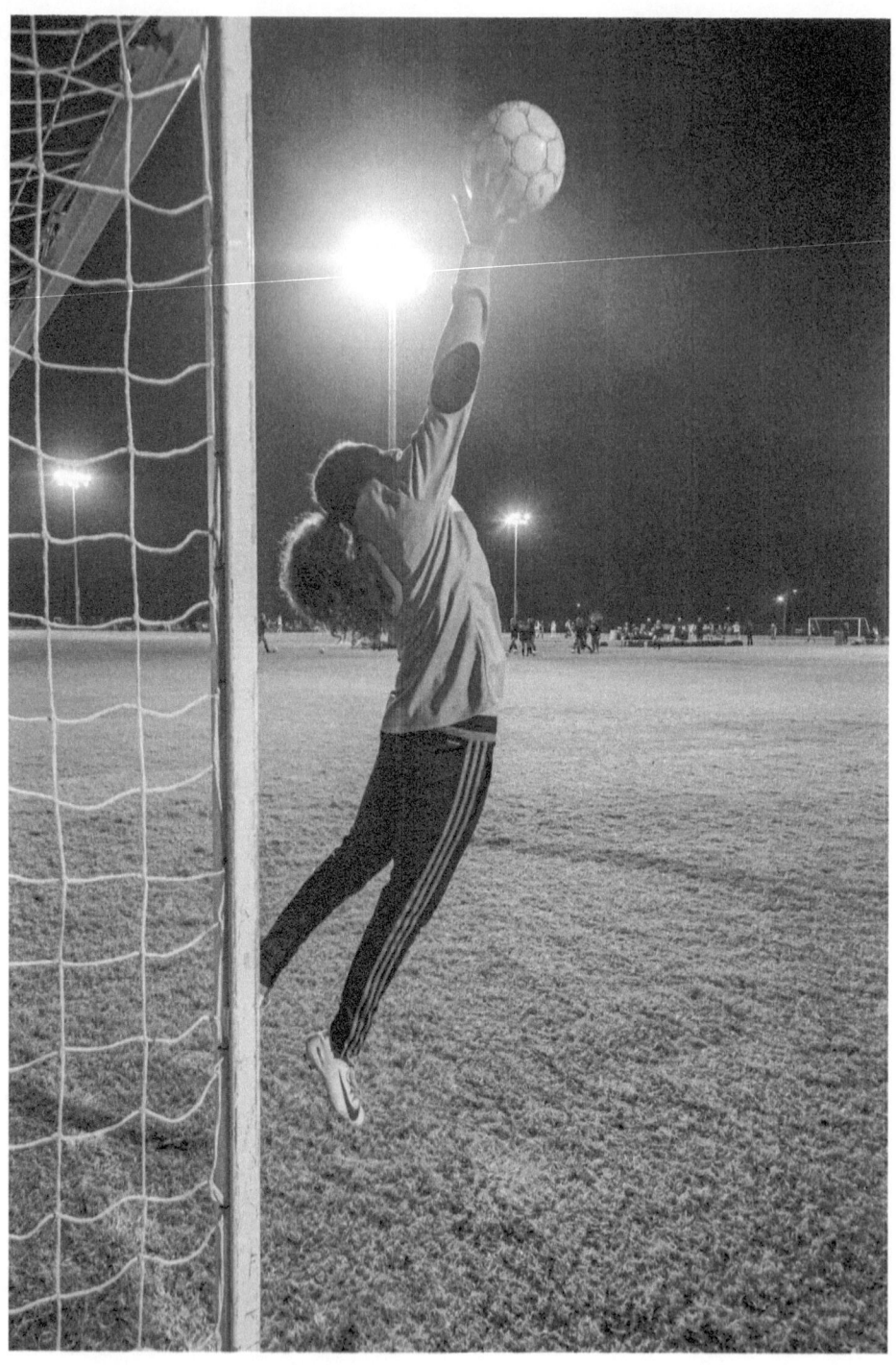

"I GOT THIS"

©2019 JIM CLARK

WHAT SPORT DO YOU PLAY?

are you more of a defensive or offensive player? what does it mean to be a good sport, write the different sports you have played and if you remember write your teams coach, the team's name, and mascot.

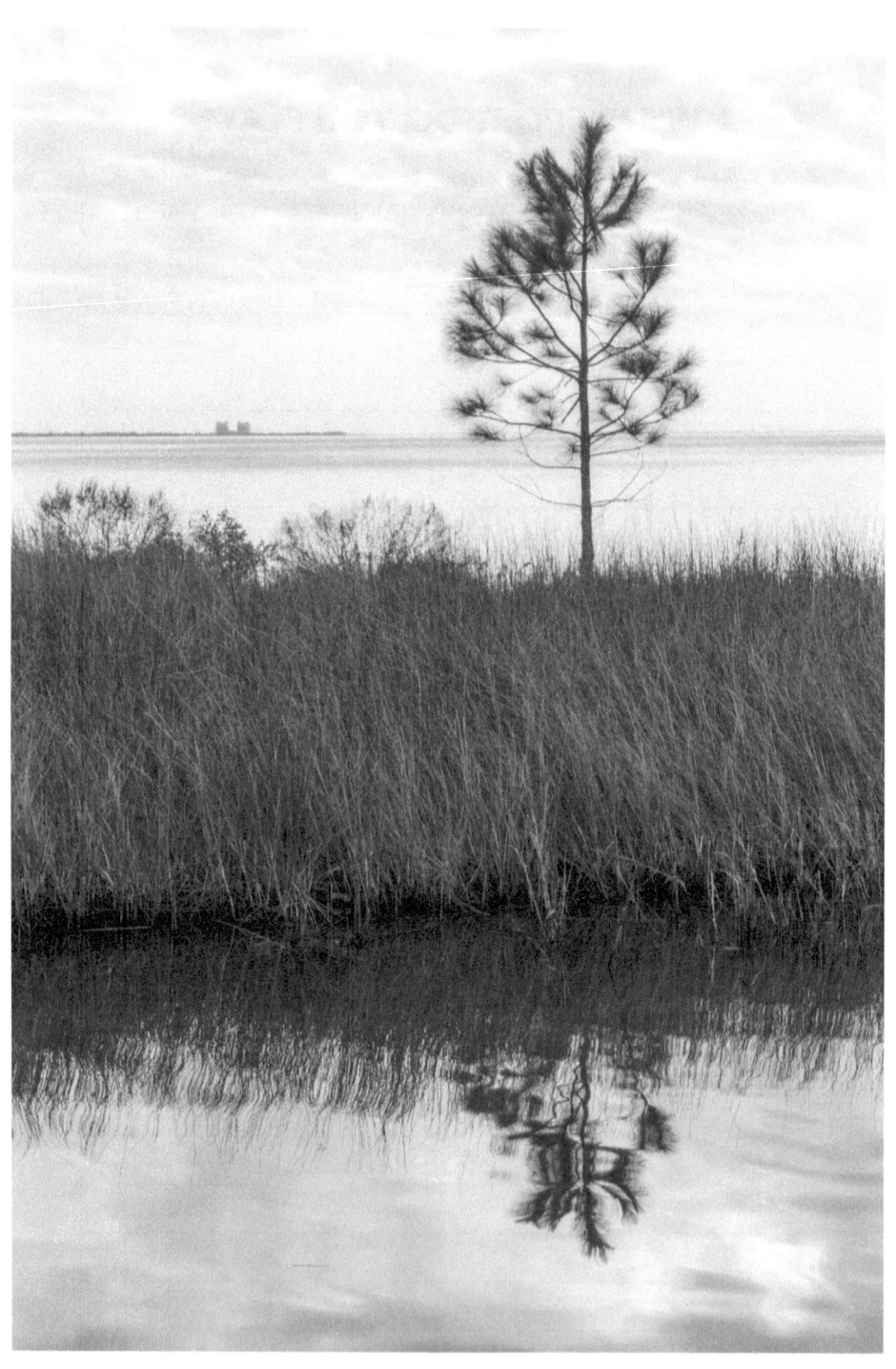

"BEHIND THE TREE" ©2019 JIM CLARK

IF YOU COULD PREDICT THE FUTURE, WHAT WOULD YOU DO WITH THAT INFO?
what would you want to see and what would you change if you could?

another day in Niceville

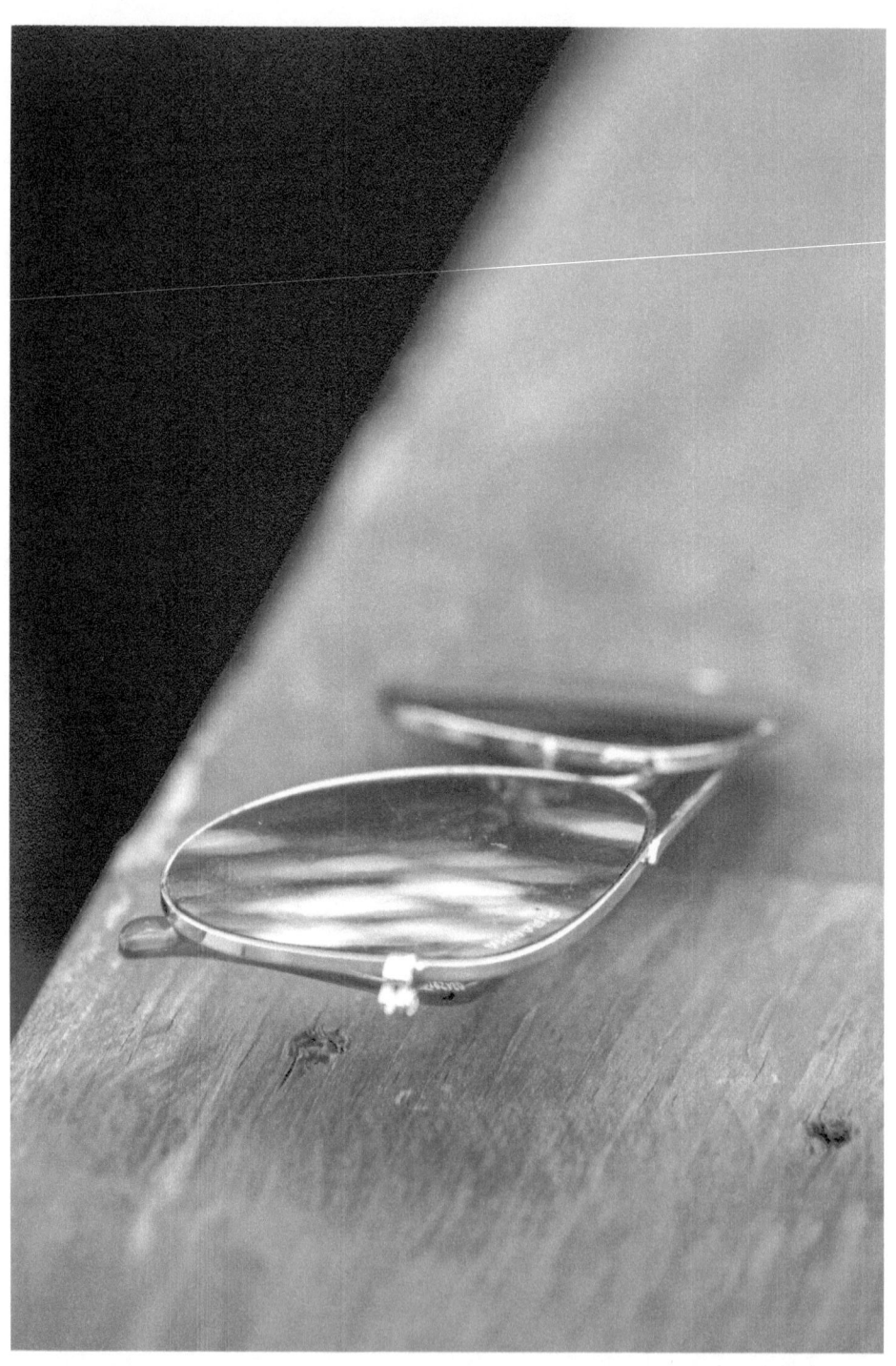

"BEHIND THE GLASSES" ©2019 JIM CLARK

DO YOU KNOW A SHADY CHARACTER?
is there someone in your past or present that's a little bit shady?
write about a few of them here and why they may be shady.

draw something down here

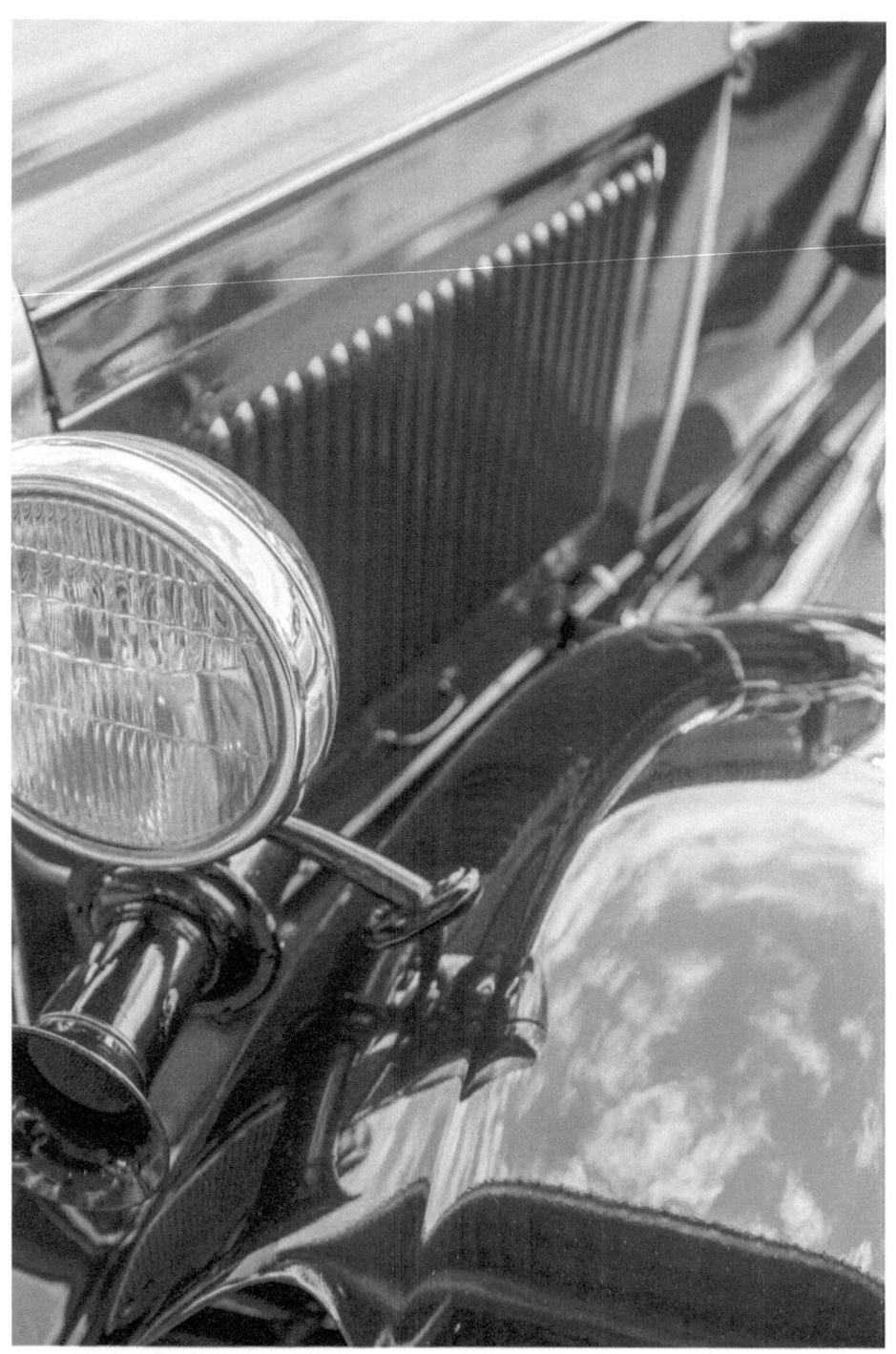

"PROM NIGHT RIDE?"

©2019 JIM CLARK

DID YOU GO TO YOUR PROM?

do you remember what it was like or not, did you stay home? what type of car did you go in? who did you go with, a date, a friend or a group of friends? write what you recall from that time in your life.

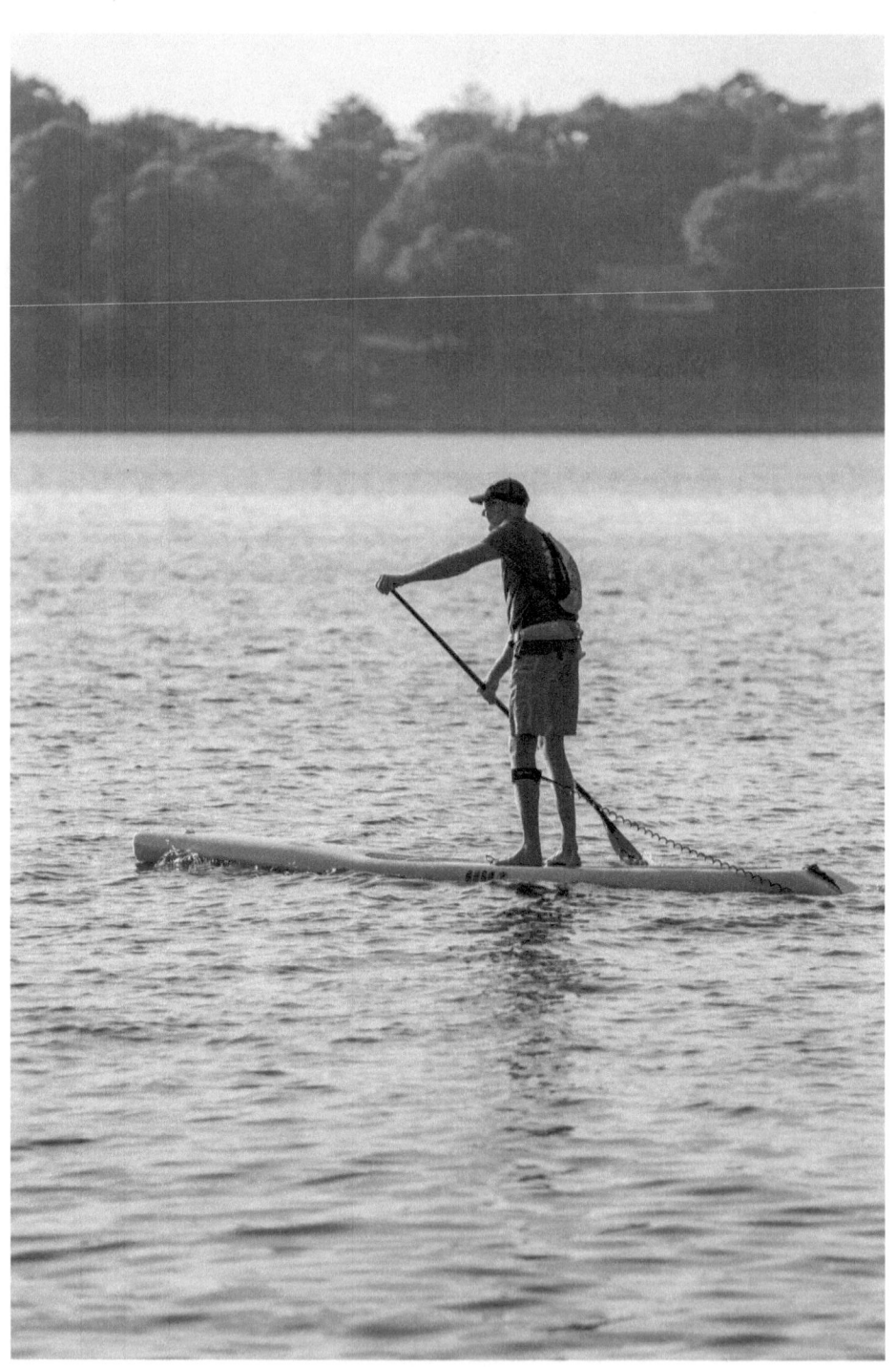

"EXPLORATION AND EXERCISE" ©2019 JIM CLARK

DRAW A PIECE OF DRIFTWOOD
it is easy to draw. make it long and skinny or short and fat with things growing out of it or resting on it

another day in Niceville

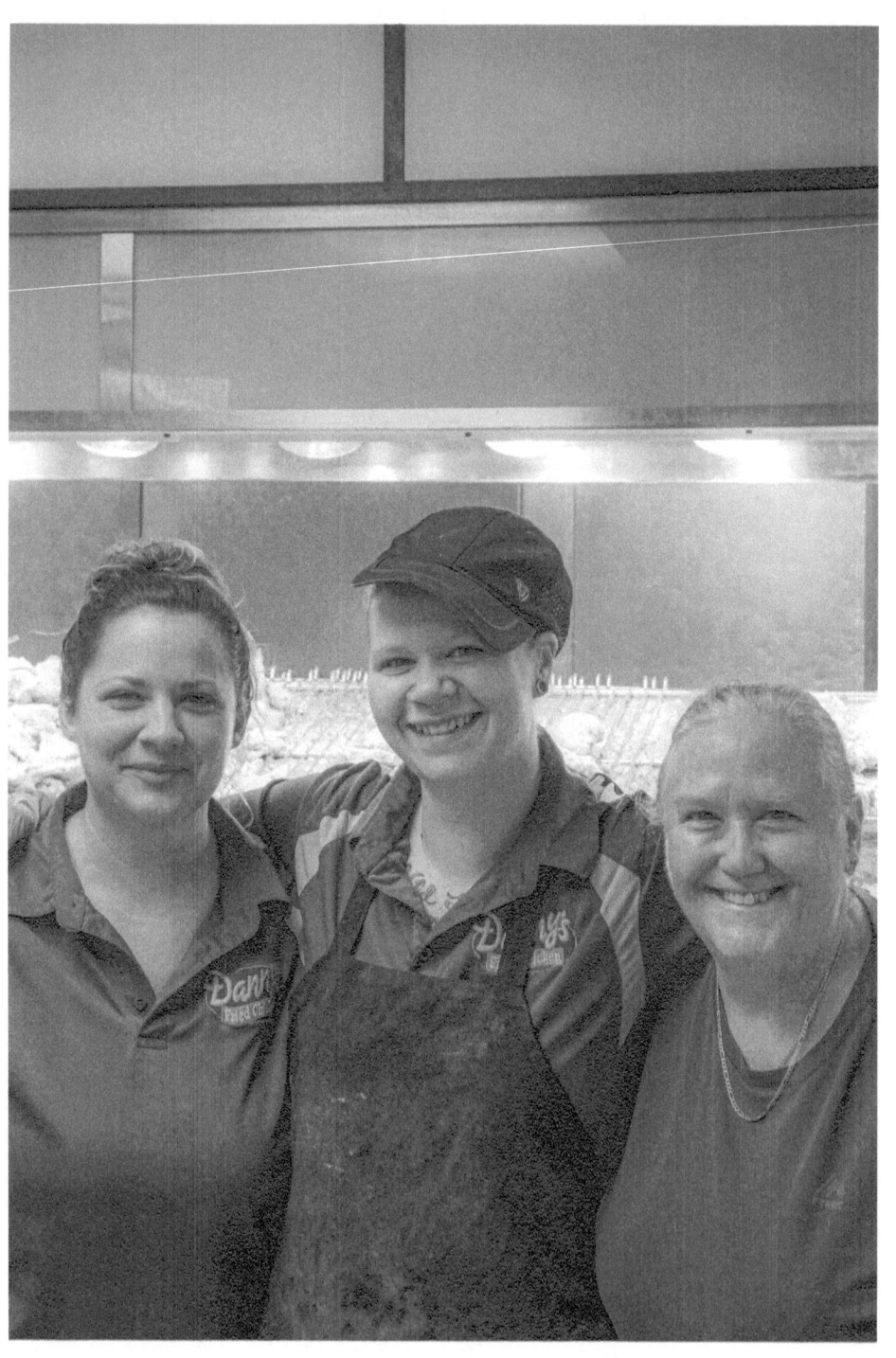

"SOUTHERN HOSPITALITY" @dannysfriedchicken ©2019 JIM CLARK

WHAT DID YOU EAT WHILE HERE?

seafood, steak, fried chicken, or fast food? write where you went to eat. would you eat there again? did you leave a tip? any comments? spill it out... we want to know.

WHAT IS THE STRANGEST THING YOU HAVE EVER EATEN?

was it sushi, fish eggs, a stinky cheese, a bug, or something else? write them down here and tell us the short story behind eating it

another day in Niceville

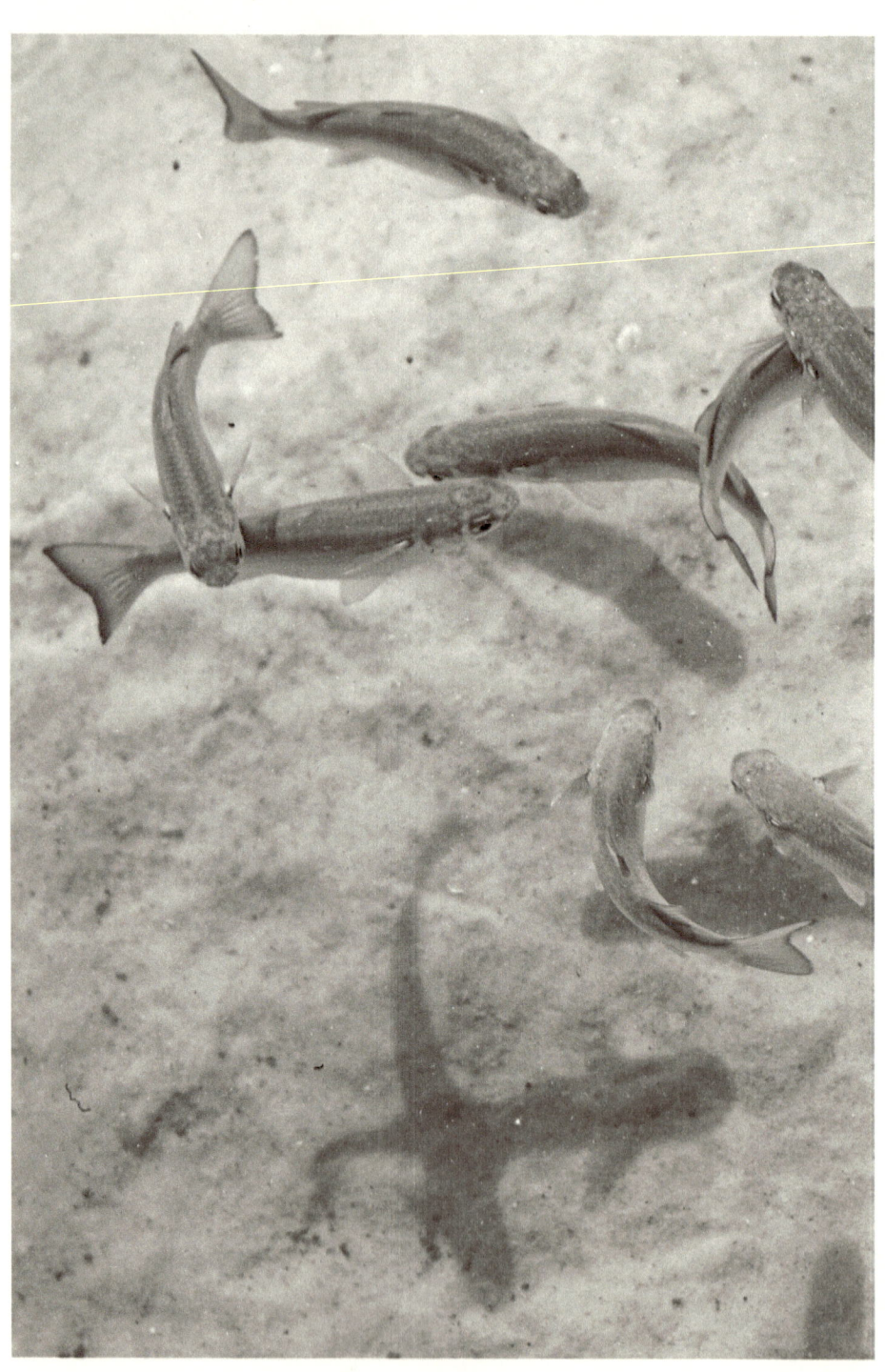

"MULLET FESTIVAL" ©2019 JIM CLARK

DID YOU GO TO THE MULLET FESTIVAL?
what do you like most of it? what did you eat or drink while there?
do you think you have to be a boggy boy or girl to attend?

draw a mullet... the fish or the hairstyle

another day in Niceville

"EXPRESS YOURSELF" @charartist

©2019 JIM CLARK

ARE YOU A CREATIVE PERSON?

write down all your creative talents - big and small. do you sing, draw, write, tell jokes, tie cherry stems in knots with your tongue?

another day in Niceville

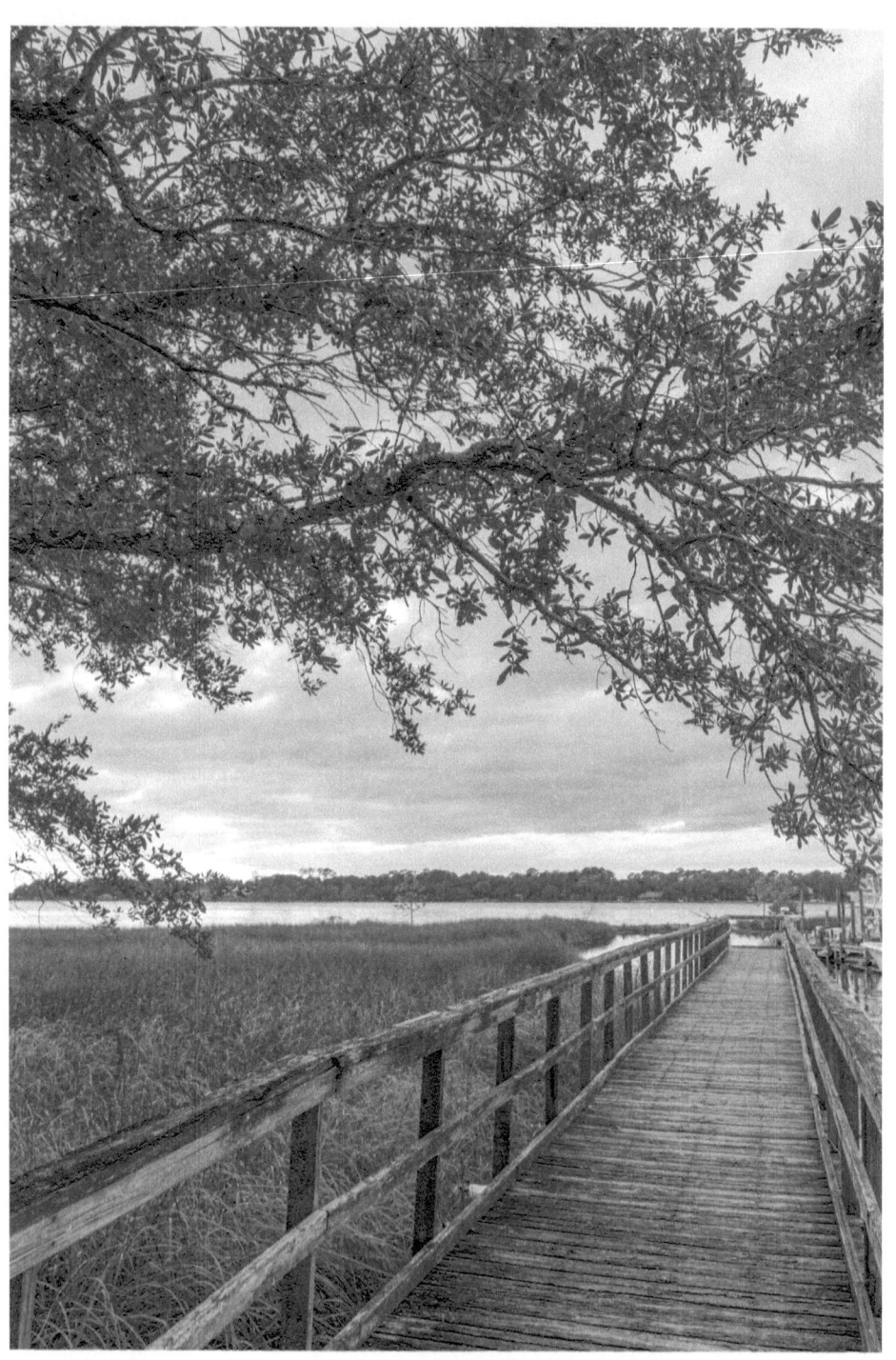

"THE RIGHT PATH?"

©2019 JIM CLARK

WHO TAUGHT YOU TO RIDE A BIKE?
your dad? mom? brother? sister? aunt? uncle? cousin? friend?
write about it. do you remember being afraid or excited?
tell us about your bike:

another day in Niceville

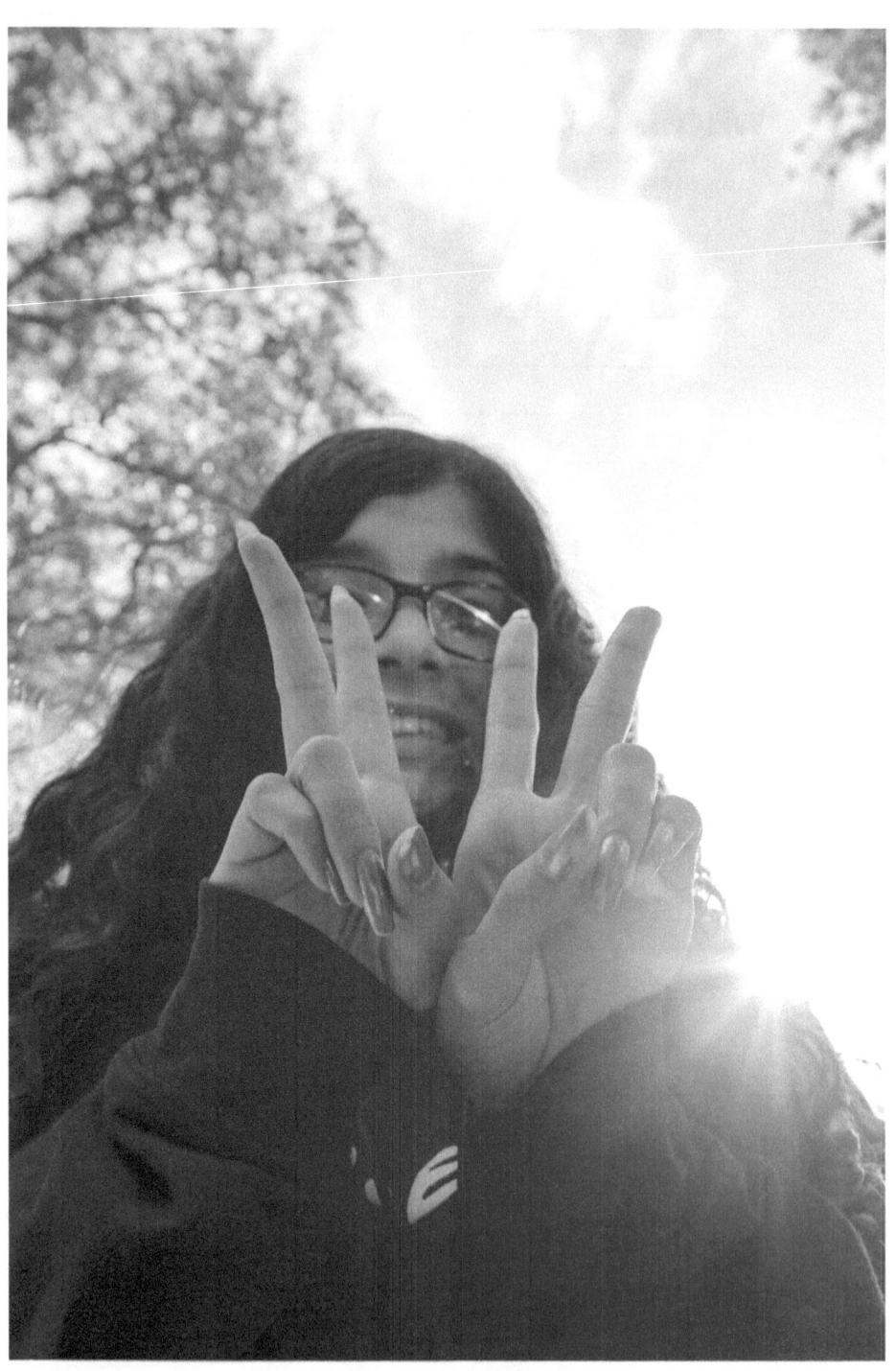

"WORLD PEACE" ©2019 JIM CLARK

WHY CAN'T PEOPLE JUST GET ALONG?
have you ever gotten into an argument with a close friend?
are you still friends today? how about with an ex gf or bf?

is world peace possible?

another day in Niceville

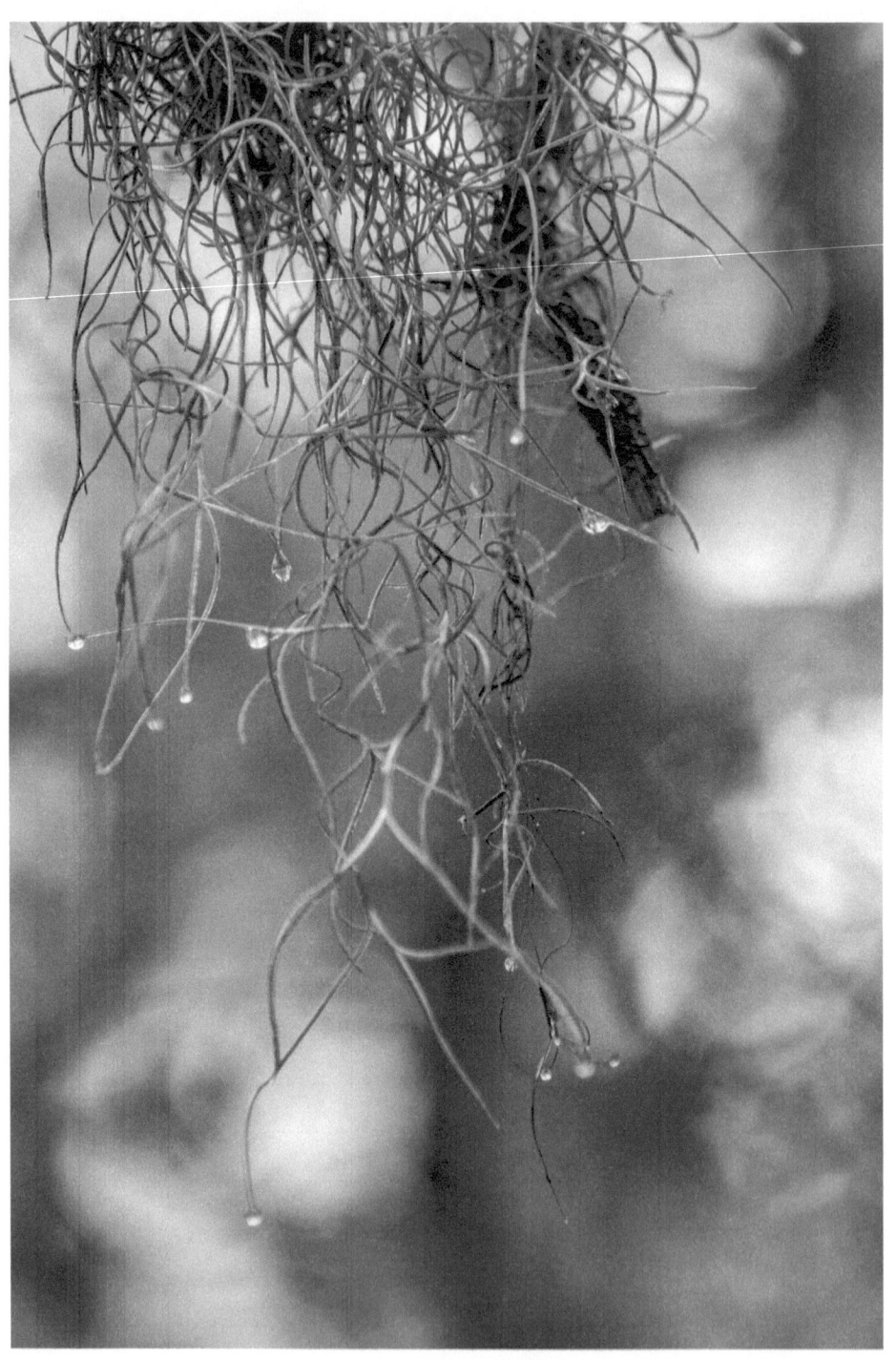

"WET AND CURLY" ©2019 JIM CLARK

WHAT'S YOUR HAIRSTYLE?
straight, wavy, curly, thick or thin, more or less... it is what it is

WHAT'S YOUR BEST FEATURE?
your cheek bones, lips, eyes, personality, or feet? ha ha ha

draw your hairstyle here on your cartoon head. i'll do it too in my book so you can see my receeding hairline and bald spot in the back. fun fun fun

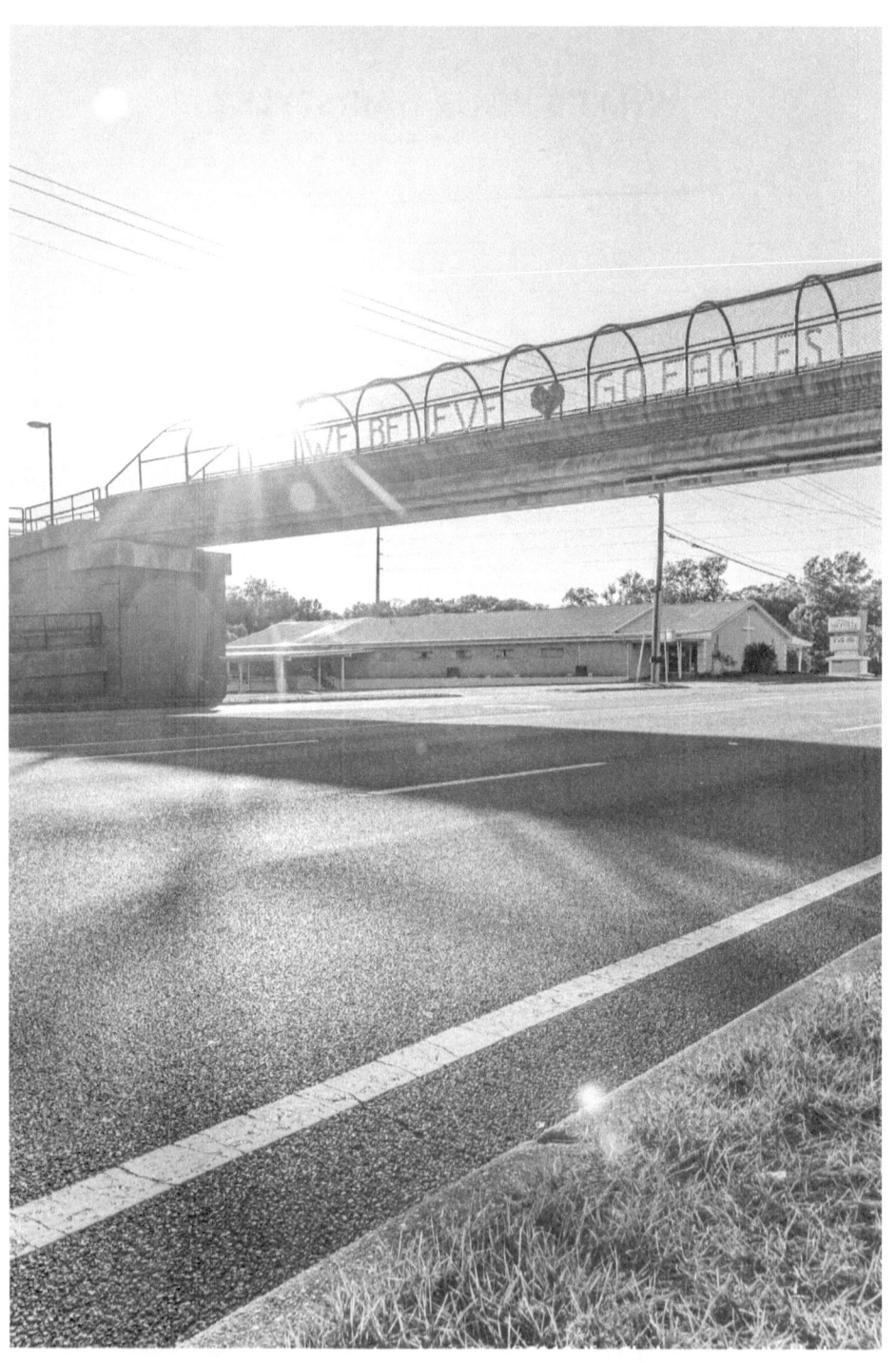

"CROSSWALK OR CROSSOVER?"

©2019 JIM CLARK

DO YOU BELIEVE IN A HIGHER POWER?

do you think there is life after death? do you believe in reincarnation? and if so, what whould you come back as? what do you think is next after we leave this earth? tell us your thoughts...

do you believe in reincarnation and if so what whould you come back as? an animal or a person or a thing

another day in Niceville

www.ingramcontent.com/pod-product-compliance
Lightning Source LLC
Chambersburg PA
CBHW021445210526
45463CB00002B/644